# HAUNTED KENOSHA

# HAUNTED KENOSHA

## GHOSTS, LEGENDS AND BIZARRE TALES

### CANDICE SHATKINS

Haunted America

Published by Haunted America
A Division of The History Press
Charleston, SC  29403
www.historypress.net

First published 2009

All images from the author's collection unless otherwise noted.

Manufactured in the United States

ISBN 978.1.59629.717.3

Library of Congress Cataloging-in-Publication Data

Shatkins, Candy.
Haunted Kenosha : ghosts, legends and bizarre tales / Candy Shatkins.
p. cm.
Includes bibliographical references and index.
ISBN 978-1-59629-717-3 (alk. paper)
1. Ghosts--Wisconsin--Kenosha. 2. Haunted places--Wisconsin--Kenosha. I. Title.
BF1472.U6S495 2009
133.109775'98--dc22
2009030569

For the love of my life, RC,
And my two exceptional children,
Courtney and Cameron,
All of whom I cherish.

For my loving father, Les,
Whom I adore.

For my beloved mother, Sue,
Whom I miss each and every day.

# CONTENTS

# CONTENTS

# ACKNOWLEDGEMENTS

Special thanks to:

Rollie C. Shatkins Jr.
Courtney K. Shatkins
Jamie (Desotell) Kersine
Carrie L. Ricard
Patricia (Dissmore) Czajkowski
Mary A. Sammons
Audrey C. Tasker
Terry L. Lawler
Alvino Perez
Thomas West
Gerald S. Rasmussen
Robert LaTessa
Bill Morelli
Joe and Rachel Potente
Gary and Dee Wier
The Woman's Club of Kenosha, Wisconsin
The Lakeside Players
The County of Kenosha
The Kenosha County Historical Society
The Kenosha Public Library System
The *Kenosha News* and all of its predecessors

# INTRODUCTION

Among other things, I am a hopeless collector of stuff. This book is a product of both my strange fascination with ghosts and my treasured collection of stuff. Over the years, I've managed to accumulate a rather sizable collection of ghost stories and legends—all of them from Kenosha County. I've saved it all—from the scribbled notes and saved newspaper articles to the interviews with normal (okay, well most were normal), upstanding citizens of this community. If it weren't for the stories shared with me by others, there surely would not be a book at all. For privacy's sake, each one shall remain anonymous.

After contemplating it a great deal, I've decided to compile the stories of the area together in one publication. My wish is to take you, the reader, on a literary "field trip" of sorts to some of the most historically haunted locations of Kenosha County. My goal is not to convince readers that ghosts exist. I feel that I've made my position crystal clear on this subject. I'm betting, though, that if you were curious enough to pick up the book and leaf through it, then that should be enough healthy curiosity of the subject to carry you all the way through to the end. My goals here are simply to entertain and perhaps even educate along the way. I do hope that you enjoy reading *Haunted Kenosha* as much as I've enjoyed writing it for you, the readers. The process has been quite a fascinating and fantastic journey for me.

In the pages that follow, we will visit many historical places of Kenosha's past. Ultimately, we will reacquaint ourselves with some of the most prominent historical figures of Kenosha. Through my hobby of paranormal research, I have become quite familiar with certain people, places and events in our beautiful county's history. Here in Kenosha, we are so extremely fortunate to have libraries, museums and resources that really are first rate. We are further blessed to have had people come before us who cared enough to preserve all they could of the past.

The stories are divided into three sections, the first of which is dedicated to a select group of historical places in Kenosha that are believed to be haunted. A brief history is given for each location, along with some interesting details.

The second section primarily focuses on local legends. Legends are best described as stories that are told and retold. Usually the stories are widely varied, due to details being added or omitted, depending on the storyteller. These are the stories that are likely to get passed down from one generation to the next. Much like the old game of "telephone," legends also will spread like wildfire through today's modern worldwide web. The fun thing about them is that they almost always are based on fact, even if they are, in fact, untrue. A tightly wound legend is spellbinding and will leave a person wondering if it could be factual. Once in a great while, though, they do actually turn out to be true. I was astonished to find that one prevalent local legend really did turn out to be true. Not only was it true, but "they" were unbelievably accurate, right down to some small details of the whole sordid affair. I guess the moral of that story is that one just never knows.

The third and final section is a collection of shorter stories, all of which are true. These are the random tidbits of Kenosha County's history that, for whatever reason, stuck out in my mind as being strange, humorous or sometimes even macabre.

Sincere gratitude is extended to each person and agency that helped, in whichever way, either directly or indirectly, with the publication of this book. Special thanks are extended to all of the good people who felt comfortable enough to share their stories with me, and also to a certain few who went out of their way to support me. Your kindness will always be remembered.

# Introduction

For all of the locations listed in this publication, please do not visit without permission or after posted hours. This is strictly forbidden and is considered trespassing. Please respect the privacy of the property owners who have agreed to let these stories be told.

For more information on the Paranormal Investigators of Kenosha, Wisconsin, please visit www.kenoshaparanormal.com.

# PART I

# GHOSTS

# Early History

Kenosha County is located approximately thirty miles south of Milwaukee, Wisconsin, and fifty miles north of Chicago, Illinois. The city of Kenosha is the county seat of Kenosha County, which is located in the southeastern part of the state of Wisconsin. Considered "the Gateway to Wisconsin," Kenosha has always been known for its extraordinary scenery.

Throughout history, the Kenosha area has been primarily an agricultural and manufacturing town. Its good citizens have produced an inordinate number of worldwide recognizable products. Of them, Jeffery Motors, Simmons Company (maker of coil spring mattresses), Nash, American Motors, Chrysler and Jockey International are but a few of the many businesses that have thrived in this community. Many of these factories that became household names have come and gone, leaving this community to reinvent itself time and time again.

Today, the city has a population of approximately ninety-six thousand and is considered to be a bedroom community, which means that it is used primarily for residential use, with most of the population commuting to jobs in other areas. In short, people like to make their homes here. It would seem as if some past Kenoshans felt the same way. Although they have long since passed on, they somehow still refuse to leave. But now I seem to be getting ahead of myself already; perhaps we should just start in the beginning...

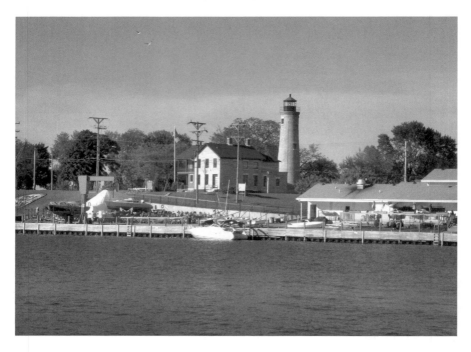

The Kenosha (Southport) Light Station. The lighthouse and keeper's dwelling was built in 1866 on Simmons Island (then Washington Island).

After the Black War ended in 1832, the Native Americans, defeated in their homeland, moved westward. Before this time, there were scattered tribal villages in Kenosha County. Two such archaeological sites were discovered in the immediate vicinity of the area known today as Library Park.

In 1835, emigration companies formed in the eastern states, particularly the Western Emigrating Company, from Hannibal, New York. Back east, people longed to head westward, as they had been told tales of lush, green vegetation, sparkling streams and lakes, open prairies filled with wildflowers and, most importantly, vast areas of premium, fertile farmland. Because these early settlers didn't arrive until the summer of 1835, they hadn't ample time to clear the land or plant full crops for themselves. This fact would become a problem later, in the wintertime. Although Pike Creek formed a natural harbor, the mouth would become, at times, almost blocked entirely by drifts of sand. Large improvements would be necessary for the harbor to be able to receive ships. So supplies were in constant great demand.

Though most of the Native Americans had moved out of the area, there were occasional wanderers who would pass through from time to time to fish, hunt or camp in the surrounding wilderness. The Indians had strange ways, a few of which upset the pioneers. Once in a while, they would find a Native American cadaver deposited inside the hollowed-out trunk of a tree. On another occasion near Washington (later renamed Simmons) Island, the settlers found two deceased natives buried upright in the ground only to their waists. The head of one, which was in an advanced stage of decomposition, had fallen off the corpse completely. These customs may have been foreign to the settlers, to say the least, but there is no known report of violence or bloodshed ensuing between the settlers and natives. The Native Americans traveled through their former territory in peace.

That first winter was a long, hard one, and many went hungry. As beautiful as the change of seasons is in this part of the country, winters are cold, relentless and long. More than a few of those early pioneers found the hardships too great and moved back east. Eight households, however, ended up staying and resolved to make this pristine land their home.

There were disputes with "claim jumpers" as well. Western Emigrating Company soon found that others came, as everyone was free to stake a claim wherever they found one until the land titles could be documented with the United States government. There were such things as "squatter's laws," which insisted that one mark off his claim, fence it in and reside on the land while clearing it. These laws were taken very seriously, and everyone seemed to know the rules.

The town at Pike Creek was born in June 1835. Pike was the name for the settlement that would become the city of Kenosha. Most of the early settlement was located in and around the area now known as Simmons Island. Almost all of the earliest buildings were erected north of the creek. For a time, the land south of the creek was deemed undesirable. The crescent-shaped creek created a natural harbor that, if improved, would be suitable for large ships. Early on, settlers started improving the swampy low spots on the south side of Pike Creek, and not long after, the settlement shifted to the more desirable south side.

History tells us that this area was also chosen because of its natural beauty. There are many accounts that specifically mention the

abundance of flowers, wild berries and grand oak trees that grew in the area. The eight-foot-tall prairie grasses, which could easily hide both a horse and a rider, are also mentioned numerous times.

Although it was beautiful, this young town had its fair share of setbacks. Fires destroyed businesses, oftentimes taking out the neighboring structures and entire city blocks as well. Diseases were spreading almost as fast as the fires, with the infant mortality rate in those days at just about 50 percent. This was partially due to the fact that there was no water or sanitation system in place.

There were even times when Lake Michigan displayed its power and swallowed up entire roads, homes and businesses, never again to be replaced. Eventually, residents grew wiser and placed large rock breakwaters along the shores to prevent further loss of land to the lake. Sometimes in the fall, storms would brew up and cause waves over thirty feet in height. Many vessels were lost on Lake Michigan during such storms.

Later, the settlers petitioned the government for help with the improvements to the harbor, and after much ado, the money was granted. In the years that followed, the name of the town was changed to Southport. It was so named because the settlement was the southernmost port of Wisconsin on Lake Michigan. When Racine County was split and Kenosha became its own county, the name was again and forever changed to Kenosha. This final name was derived from the Native American name "Kenozia," which meant "of the pike." Pike is still the name used for both the creek and the river that empties into Lake Michigan near Pennoyer Park, where the band shell is located today.

Most of the founding citizens were highly educated people. The settlers quickly established stores, schools and churches. Kenosha's first citizens put great emphasis on education. The first free school "west of the Allegheny Mountains" was established at Pike Creek in 1845. Early log-style schools in those times often pulled double and triple duty as meeting halls, social venues and church service locations. Theirs was the kind of community that truly helped one another. When the first churches were made, each denomination helped the others to build their churches. Kindness was the rule, rather than the exception, as many pioneer households, with barely enough to eat, found themselves feeding hungry strangers. The settlers also took travelers in out of the cold and shared their meager comforts with

them. These people had tremendous will, however, and somehow they survived it all.

The year 1836 saw many more newcomers to the settlement. One of them was named Charles Durkee. Mr. Durkee and his wife, Catharine, were newlyweds. It is here that our stories begin...

# The Library Ghost

In June 1836, violent storms drove a small group of settlers off the choppy Lake Michigan waters and onto the shore of a brand-new settlement. Among the passengers bound from Chicago to Milwaukee that day were Charles and Catharine Durkee, originally from Vermont. Mrs. Durkee had become so violently ill that she begged to be put ashore. After a few days' rest, Mr. and Mrs. Durkee grew so charmed by the beauty of the area that they decided to stay and make their home in what was then called Pike Creek. Charles Durkee built a log cabin to the south of the city, on the southwest corner of what is now Library Park, very near where the Gilbert M. Simmons Memorial Library is today. History tells us that at that time, there were wildflowers growing on the property in a magnificent display that rivaled the best gardens man could create. Although Mrs. Durkee never planted a flower on the land, there was a splendid variety just outside their door all season long. Mrs. Durkee was reportedly as happy living in that small cabin as if she were living in a fine mansion back east. By all accounts, the couple was very much in love and looked forward to what the future would hold for them. The young bride was also noted as possessing exceptional beauty and a pleasant disposition.

Sadly, Catharine Putnam Dana Durkee would not enjoy her new home for long. Tragically, she died of illness at the age of twenty-five in August 1838. She was laid to rest on a picturesque grassy knoll on the southern end of their property. That area is now known as Green Ridge Cemetery. She personally chose the grave site before her death. She remarked to her sister while walking one

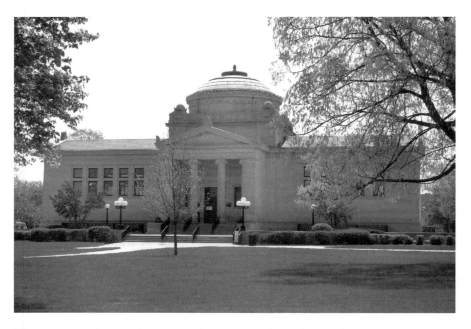

The Gilbert M. Simmons Memorial Library, a gift to Kenosha from Zalmon G. Simmons. It was dedicated on Memorial Day 1900.

day that if she were to die, she would like to be buried in that spot. Catharine had loved that particular area. It is said that Charles Durkee loved this woman immensely, and that he never stopped mourning the loss of his precious Catharine. It was whispered that she may have even been pregnant at the time of her death. Charles Durkee, owning vast real estate in Pike Creek, donated large tracts of land surrounding Catharine's grave to be used as a burial ground. Not long after, he donated the land that their cabin had been on to be used toward a New England–type commons, called City Park, or sometimes referred to as the Commons. A man named George Kimball donated some land as well. That area is known today as Library Park.

At some point, the town put a white picket fence around City Park. In earlier years, cows had been known to graze there. The fence was a deterrent to keep the livestock out of the park. By the 1870s, the ancient oaks in the park were dying, and the fence was looking pretty shabby. The ladies of the city organized a park association and raised money to improve the park's condition. The fence was torn down and

weeds and brush were cleared. The park was once again respectable; however, once the fence came down, boys continued to occasionally drive cows through the park, which always upset the ladies and the workers considerably. The association decided to install a pond to spruce up the park a bit. When the pond was finished, the boys still drove the cows through, and townspeople petitioned to have it stopped. In the winter of 1881, the pond was used for ice skating, and everyone enjoyed it for one season. The next summer, a large colony of bullfrogs moved into it, and their croaking became such a nuisance that the residents near the park complained bitterly. Two years later, it was filled in and a gazebo was erected in the park, where concerts were given regularly.

Zalmon G. Simmons was born to parents Ezra and Maria (Gilbert) Simmons on September 10, 1828, in Montgomery County, New York. He was the oldest son. The Simmons family traveled westward and ended up settling in Benton Township, in Lake County, Illinois, after a brief stop in Southport. At that time, Zalmon was fourteen years old. He worked for his father on their farm and taught school until he reached the age of twenty-one. At that time, he packed up his belongings and his life savings of three dollars and moved to Southport. Shortly after arriving in Southport in 1847, Simmons went to work for Seth Doane in his store. A short time later, he ended up owning that store. He married Emma Robeson, and together, they would have a total of six children. As far as business dealings were concerned, Simmons seemed to possess the Midas touch. Very few of his business ventures were failures, and he shared generously of his wealth with the community. He was bank president and served a term as mayor of Kenosha. Ultimately, he founded the Simmons Manufacturing Company, which became world famous for its coil spring mattresses. Although he did not fight in the Civil War, he was considered a friend to the Union's cause and reportedly idolized Abraham Lincoln. To each volunteer who enlisted, Simmons gave a gold coin worth five dollars. He continued his support by giving the families of each volunteer an allowance of five dollars each month.

Many decades later, in 1899, Zalmon G. Simmons offered to build for the city a much needed library. He offered this gift to the residents with only two conditions: that the city had to levy a property tax to support the cost of operations; and that he wished it to be named

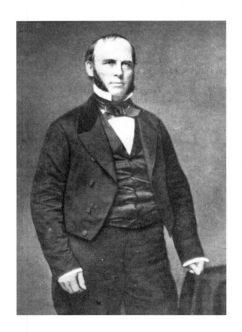 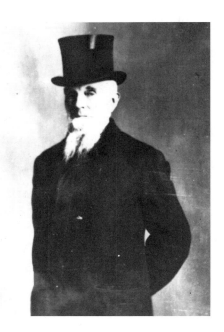

*Above, left*: Charles Durkee, congressman, senator and territorial governor of Utah. He arrived at Pike Creek with his wife, Catharine, in 1836, and later married Caroline Lake. *Courtesy of the Kenosha County Historical Society.*

*Above, right*: Zalmon G. Simmons, one of Kenosha's most distinguished leaders. He founded the Simmons Company, served as mayor, gifted a library and was a friend to the city of Kenosha. Photograph by Louis M. Thiers, circa 1900. *Courtesy of the Kenosha County Historical Society.*

in memory of his deceased adult son, Gilbert Maurice Simmons, who had died of pneumonia about ten years earlier. The city quickly agreed, so Z.G. Simmons hired nationally acclaimed architect David H. Burnham to design the building. The building itself is a grand example of the Neoclassical Revival style, built with Bedford limestone and decorated with marble, bronze, mosaics and frescoes. The structure was erected in the shape of a raised Greek cross. It was proclaimed that this structure would be built to last for one thousand years and that only a nuclear bomb, or outright human neglect, could destroy the sturdy building. On May 30, 1900, the new library was dedicated with a grand celebration, and a new soldiers' monument was unveiled as part of the ceremony. The library and grounds still remain very much as it was today.

That is, except for the fact that the library now is reportedly home to a ghost. Over the years, many library employees who have worked at the Simmons branch have reported strange happenings in the evening hours. Some people have discounted these stories, claiming that they were a product of somebody's vivid imagination. Others who have experienced the activity may not be so quick to agree.

On October 26, 1997, Debbie Luebke Metro, *Kenosha News* journalist, reported that one summer evening, at closing time, two library employees were locking up for the night when the security system started acting up. For whatever reason, the keypad wouldn't let them key in the security code. Then they both heard the distinct sound of a wooden chair sliding across the marble floor upstairs. As one can imagine, this was very disturbing to the two library employees. Thinking that they somehow must have overlooked somebody inside, they went back up the metal spiral staircase to investigate. They found that everything seemed to be in order. They were in the process of shrugging it off when they suddenly heard a mysterious series of tapping noises that seemed to come from all directions. Deciding that they had had enough, they punched in the security code one last time and promptly left the building.

A few years later, one of the aforementioned library clerks was entering data for the *Kenosha News* when she entered the library on a Sunday when it was closed, taking care to lock the door behind her. Going on about her business, she heard light footsteps coming up the stairs. Later, she reported that she had heard what sounded like books falling off the shelves. Another time, an unseen woman from behind her said, "Excuse me," as she washed her hands in the sink. Reportedly, another employee was told by an unseen female, "You should leave now," as she sat and ate her lunch in the break room. Legend has it that she stayed and finished her lunch, even though she had been startled by the interruption.

At least one aide of the library, who has since transferred to a different branch, has had similar experiences. She stated in an article in the *Kenosha News* that the security buzzers would simultaneously go off when no one was passing through them. When she walked through the building at closing time, she felt as if someone were following her in the darkness. One night, she also heard those wooden chairs moving across the marble floor. Again, nothing was out of place when she went back upstairs to investigate.

For the most part, the Simmons Library ghost would be classified by ghost researchers as a poltergeist, which means that it is noisy and is heard more often than seen. Only one person, a custodian of the library, is reported to have seen the ghost. While changing a light bulb in the basement early one morning before the library opened, it is said that he saw a female walking down the hall when nobody else was there.

Various employees have also heard the toilet flushing in the men's room when nobody else was around. They hear rustling newspapers, books falling, strange tapping sounds and, of course, the heavy oak chairs sliding around on the marble floor. None of these things has ever been explained rationally.

## THE LADY OF HALE-FARR HOUSE

By the end of 1861, almost all of the lots were taken in the area that surrounds present-day Library Park. Just west of the Simmons Library is the Hale-Farr House, better known as the home of the Woman's Club. Built in 1848, this immaculately kept building is a must-see for anyone who hasn't had the pleasure. It is so nice, in fact, that it seems as if some former occupants do not wish to leave.

Samuel Hale walked from Chicago to Kenosha in 1836. Being a successful merchant, he had a home built in the upscale Library Park Historic District. The original home was a two-and-a-half-story Italianate dwelling. Although Hale was a very successful pioneer businessman, he is probably best remembered for the way he would announce incoming ships. "Man the lighter!" he would call out, and every available man would drop his work to lend a hand, day or night. Sometimes, he was known to give the doors a firm kick, which would certainly wake the occupants. A lighter was a smaller boat used to carry people and goods to shore before the proper harbor was built. Large ships could not come in that close to shore, due to shallow waters and sand dunes. In those early days, workers had to

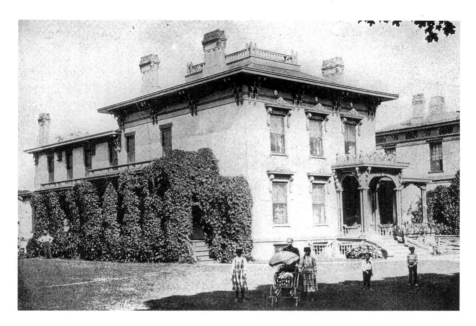

Dr. Farr's Residence, circa 1897. *Courtesy of the Kenosha County Historical Society.*

throw shipments of lumber overboard so that the pioneers could retrieve it once it had floated to shore.

This property is also acknowledged as being a station of the Underground Railroad in the years preceding the Civil War. Both Samuel Hale's property and Reuben Deming's residence (across the park) were locations that provided a safe hiding place for runaway slaves. The fortunate ones who made it this far north without being recaptured were hidden in undisclosed locations until they were stowed away, usually on northbound ships leaving Kenosha's harbor.

Dr. William M. Farr was a surgeon with the Chicago & Northwestern Railway and also had a thriving private practice. He served three times as the mayor of Kenosha and also served on the city school board. Sometime about 1890, his wife, Beatrice Isabella (Keith), purchased the Samuel Hale property. It was about this time that extensive remodeling was done to the building. At some point during renovations, an attic ballroom was added, which was used for roller skating, among other things. The late nineteenth-century décor is still proudly preserved today.

From 1916 to 1923, Horace Johnson and his family occupied the premises. Johnson was a knitting room supervisor at Cooper Underwear Co. (later Jockey International). Several years before, he had invented the "closed-crotch" style of men's underwear, which was all the rage of the times and ended up making a good fortune for both him and the company.

The Kenosha Woman's Club purchased the building from Horace Johnson in 1923 and has called it home ever since. The Woman's Club was organized on April 29, 1891. Its membership is dedicated to community service and intellectual and social culture. During its ownership, it has expanded and improved the home as necessary. In 1951–52, the kitchen was remodeled and a large banquet room was added onto the rear of the building; this room is rented out for parties and other special events. None of the ladies live in the home, but there has always been a caretaker in residence who is responsible for the upkeep of the fine property. Most of the members say that they have not experienced any ghostly phenomena during their time spent in the home. The caretakers, however, have had somewhat different experiences.

One of the things they all speak of is seeing a woman's figure dressed all in black that floats down the grand staircase from time to time, only to disappear when she gets near the bottom. The woman is described as wearing period clothing from perhaps the late 1800s. Another strange thing that is reported is noises that are often heard in the ballroom at night. The noises sound as if something very large is walking around up there. Even so, the spirits that roam throughout the Woman's Club seem to be more of a friendly sort. There are no known reports that they have shown bad intent or that they've caused any harm to anyone.

A former caretaker reported that late at night you could hear someone walking in the hallway of the second floor, where the caretaker's private living quarters are located. The floorboards are very old and, thus, extremely creaky. When he would look, nobody would be there. These events would leave him worried that someone had entered the house somehow, so he would make his rounds to check the whole house for intruders. None was ever found. This particular caretaker knew other previous residents who had reported strange happenings as well. According to those witnesses, a boombox-type radio is said to have turned off and on

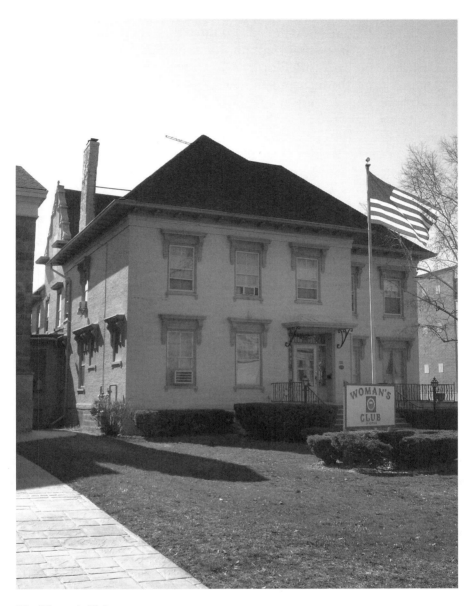

The Woman's Club.

at random, all by itself. They also reported hearing the sound of a bell, much like the kind of bell that someone would attach to a cat's collar, when no cat resided there.

Another time, the husband and wife who were serving as caretakers at that time were having their grandchild over to spend the night. The wife was busy seeing to the grandchild when she saw a figure out of the corner of her eye moving toward the kitchen area. Assuming that it was her husband, she called out to him. When he answered from behind her, nowhere near the direction of the kitchen, she was puzzled. Who was it that she had seen just moments before?

Once, this same caretaker saw the figure of a female peering into a doorway. She was described as being of muted color, with white hair. Her skin looked flesh colored, but pale. The caretaker said, "It looked like she might have had lipstick on, or something."

More recently, another caretaker was cleaning the beautiful leaded-glass windows in the entryway. He was trying hard to get into every crevice of the metalwork when he got the feeling that someone was standing behind him. Just as he turned around to have a look, he saw two dark forms flee into the adjacent parlor. He described them as being very dark and not appearing to have defined limbs or features. They were floating off the ground and were adult-sized, in his estimation. Just as suddenly as he spotted them, they were gone.

Sometimes, he states, he comes downstairs in the morning to find lights turned on that he knows he had turned off the night before. Other times he sweeps the entry hallway at night only to discover all kinds of debris covering it the next morning. He says that the debris on the floor is such that it appears as if many people have walked through during the night.

We may never know for certain who exactly inhabits the Kenosha Woman's Club. For now, we will just count our blessings that the spirits that stay on are not prone to being malevolent.

# BRIDGET McCAFFARY'S GHOST

At first glance, it looks like a peaceful dwelling. Gazing upon it, a person can easily see how it appeared about 1850, when it was first constructed. The building is remarkably well preserved. Little has changed on the outside, except for the missing outer stairwell that used to be present on the south side of the building. The home has also been converted from an apartment house to a single-family residence that is now owner occupied. If you didn't know the history of the property, I bet you would never guess that a man had murdered his wife in the backyard, and that the husband was hanged here in Kenosha for her murder.

John McCaffary, an Irish immigrant, came to America by way of Burlington, Vermont, in May 1837. In 1846, he applied for U.S. citizenship. In August 1847, he purchased a plot of land in a respectable neighborhood at the then western edge of Southport (now Kenosha) for eighty dollars. This lot was purchased from Charles and Caroline Durkee. Not long after, he built a two-story brick home on the land. Church records show that on May 2, 1848, he married Bridget McKean at St. James Church in Southport.

They had been married just over two years when something went horribly wrong. Sometime about midnight on July 22, 1850, neighbors heard a ruckus and a woman's cries. The cries of, "Oh John, spare me!" and "Oh John, save me!" were heard over a block away. The concerned neighbors awoke and rushed over to the couple's property to find John McCaffary emerging from the direction of a stagnant hogshead well in their backyard. Some witnesses testified that they had heard splashing noises upon arrival, as well. When the neighbors questioned John McCaffary whether his wife was in the well, he replied vaguely that someone was in the well. Residents rushed over to the well and saw a white shirt inside. On further inspection, they discovered Bridget McCaffary's lifeless, bruised body inside. Inside the well, they also found John's hat and one shoe. John's other shoe was found in the area between the well and their house. The muddied shoe appeared as if it too had been in the well. Since the stagnant well only contained eighteen to twenty inches of water at the time, it was apparent that John had tried to drown his wife, and when that proved unsuccessful, he proceeded to stomp on her head until she expired. After examining Bridget's

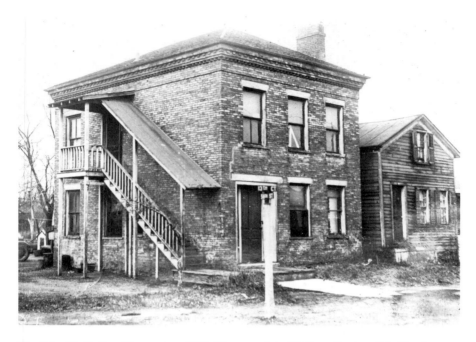

The John McCaffary House, circa 1931. Photograph by N. Otto. *Courtesy of the Kenosha County Historical Society.*

body, a physician stated her cause of death as drowning. The mayor at that time was Colonel Michael Frank, who lived only three blocks away. Someone sent for the mayor and roused him from sleep. When he arrived, he arrested John McCaffary, who had gone inside and changed into dry clothes.

This was the first recorded murder in Southport. Because the city had no official jail at that time, the accused was taken to Racine and held for a period of about two weeks. He was brought back to Southport and remained in custody until his trial began in July 1851. His murder trial lasted for ten days, after which John McCaffary was found guilty and sentenced to death by hanging. He never testified in his own defense, nor did he ever give a reason for committing his act. He took his reasons with him to his grave.

Legend says that somewhere between two and three thousand people witnessed the public hanging. The gallows were erected about half a mile away, south of McCaffary's home. Before his execution, John McCaffary finally admitted the horrible thing that he had done.

His last words were of forgiveness for the people who had testified against him in court.

The execution was a botched operation, at best. Instead of being dropped through a trapdoor on the platform, a spring-loaded mechanism raised the victim up into the air. This caused the condemned man to strangle slowly instead of having his neck snap instantly. After he hung there for eight minutes, doctors checked him for a pulse. The physicians found that his pulse had only slowed slightly, and they let him hang for ten more minutes until he was pronounced dead. After his expiration, they lowered him directly into a coffin and then buried him at Green Ridge Cemetery in an unmarked grave.

In 1978, the McCaffary house was listed on the National Register of Historic Places. This was done not because of the gruesome murder that took place in the yard, but because this man's execution was the first and last capital punishment carried out by the newly formed state of Wisconsin. (A few other executions are known of, but none was carried out in the name of the State of Wisconsin.) Many citizens were outraged by the hanging. Many Wisconsin citizens claimed that they did not object that the law was carried out; rather, they objected that the law existed in the first place. In 1853, the death penalty was repealed in the state of Wisconsin. It has remained so ever since.

Local legend has it that even though Bridget had been dead and buried for over a year at the time of John's hanging, she may have lingered in spirit. An early newspaper article revealed that McCaffary himself claimed that his bride had visited him on several occasions in his last days at the jail. He claimed that Bridget had returned to taunt and charge him with his crime.

For the next half a century or so, there was also a series of articles in the newspaper that suggested that the McCaffary home was haunted. Apparently, tenants would not stay long in the building because disturbing noises kept them awake all night. No one could get a good night's sleep in that house.

It seems as if Bridget's ghost was not exclusive to the McCaffary property, either. In a *Kenosha News* article by Debbie Luebke Metro dated October 31, 1999, one former owner of the property declared that some very strange things had happened while he resided both in the house and in a neighboring house that adjoins the McCaffary property. Local lore suggests that John McCaffary chased his wife around the two yards until he caught her and plunged her headfirst

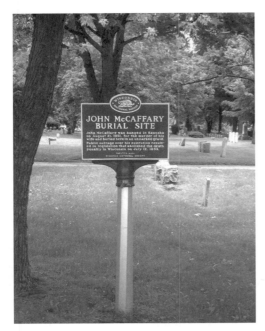

*Left*: John McCaffary burial site. McCaffary was buried in an unmarked grave until 2001, when the Wisconsin Historical Society erected a marker on this site.

*Below*: The McCaffary House.

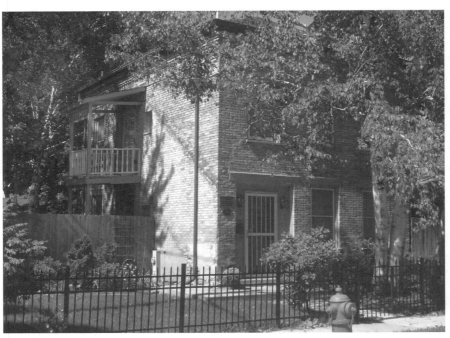

into that well. It was reported in the newspaper article that this former resident was sitting with a friend in the neighboring house when his friend became suddenly startled at seeing a woman's face in the window. That window was reported to be at least ten feet off the ground.

A few years later, this former owner went on to say, he was sitting in the McCaffary house with some friends when one person reported seeing an apparition in the doorway to the living room area. Another time, he clearly heard someone walking the floor in the upstairs apartment that was newly vacated at a time when he was alone in the house, except for his dog.

Even though the paranormal activity didn't seem to be hostile in nature, many people have reported that the house had a "bad feel" to it. It was also noted that, upon leaving, residents felt as if a weight had been lifted—as if they had emerged out from under some unseen supernatural oppression.

At the time of print, the newest owners of the house have been there for two years and have no paranormal activity to report...yet.

# THE LEGENDS OF KEMPER HALL

She's been seen. She's been photographed. She has spoken aloud. She is the ghost nun of Kemper Hall. For nearly a century, she has wandered the dormitories and steep spiral staircase that leads up the five-story observatory tower.

This meandering maze of structures was originally a single residence. Durkee Mansion was built in 1861 as the private home and grounds of Senator Charles Durkee and his second wife, Caroline (Lake). In 1865, Senator Durkee left Kenosha for health reasons and was appointed the territorial governor of Utah. At that time, he made his property available to the Kenosha Female Seminary. By 1871, the mansion had become an Episcopalian boarding school for girls, called St. Clair's Hall (or Academy), operated by the Community of the Sisters of Saint Mary. Soon after, the name was changed to Kemper

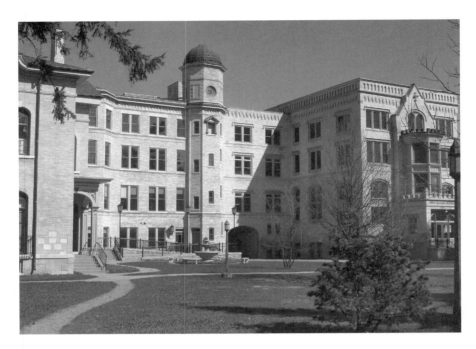

Kemper Center.

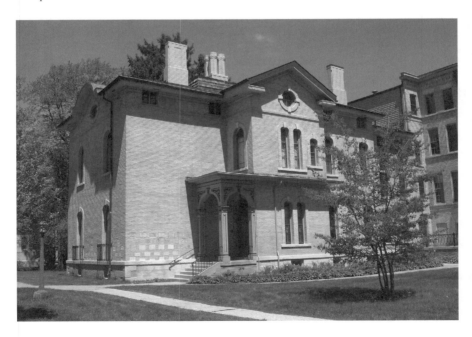

Durkee Mansion.

Hall. That same year, a large wing was added to the rear of this mansion. Later, as needed, the sisters added all of the other buildings on the campus. In 1875, the Gothic Revival chapel was added, highly decorated with a rose window and a bell tower that no longer exists today. A wing connecting the chapel to the original mansion was built about 1876. The sisters used the first floor of the new wing for a music room, and the second floor served as the infirmary. A four-story dormitory building was erected in 1894 and connected to the existing structures. This included a five-story observatory tower and a wooden spiral staircase. Another dormitory/gymnasium was added to the south side in 1901, connected to the northern dormitory by an arched passageway. The convent, which is the building on the north end that is three stories in height, was constructed in 1911 and was joined onto the chapel with another connecting wing.

By all accounts, the all girls' school had an impeccable reputation for serving the community. It had outstanding enrollment, especially considering how the early citizens of Kenosha had already set up quality education within the public school system. Kemper educated the daughters of many prominent citizens, even drawing enrollments from other parts of the Midwest. It is said that its science program was extraordinary at a time when some would have felt it unnecessary for young ladies to excel in the sciences. Sadly, because of economic reasons, Kemper Hall closed its doors forever in 1975. The grounds and buildings sat vacant for a time. They were saved from decay or, worse yet, development in 1977, when the campus became part of the Kenosha County park system. The complex was also listed on the National Register of Historic Places in 1976. It is now known as Kemper Center. The buildings provide the public with extraordinarily elegant rental facilities for weddings, business meetings and other special occasions. At Halloween, the Teen Task Force operates its annual haunted house attraction here, which is widely received and different from one year to the next.

There are many unsettling stories associated with Kemper Center. One well-known tale involves a nun who is said to appear on or around the infamous spiral staircase that leads up to the observatory. It is this spectral nun that the older girls would warn the younger girls about. This ghostly presence appears at random, always dressed in her habit.

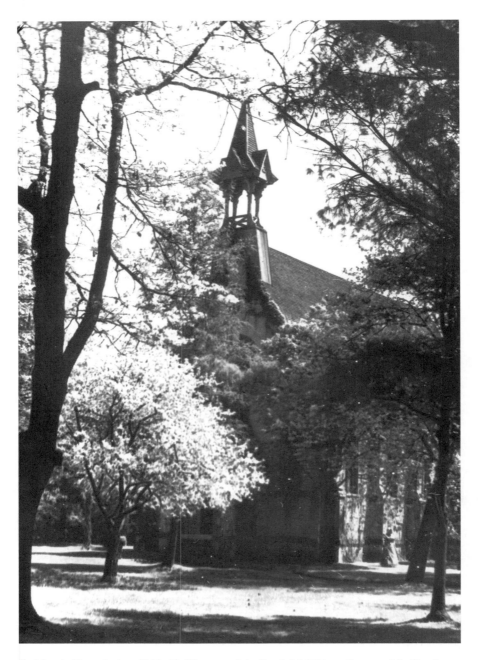

St. Mary's Chapel, circa 1900–09. Photograph by Louis M. Thiers. *Courtesy of the Kenosha County Historical Society.*

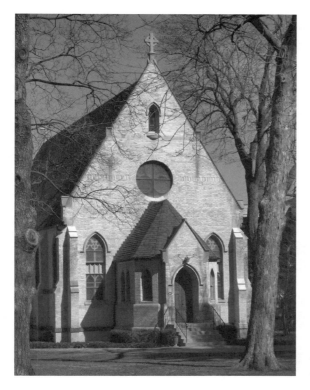

The chapel at Kemper Center.

Many think her to be the ghost of Sister Margaret Clare, who was the sister superior in charge of Kemper Hall from 1878 to 1917, when she retired. Stories claim that she was a cruel nun who ruled with an iron hand. Legend has it that Sister Margaret Clare fell, or was pushed, to her death down a different wooden staircase located on the campus. There is no evidence of this happening. Sister Margaret Clare was born Margaret Garvey to Mark and Mary Garvey of Michigan on October 13, 1838. Before entering the community, she had been a Civil War bride. After her husband was killed in battle, she became involved with the community of the Sisters of St. Mary. Although she was a no-nonsense kind of woman, she was deeply beloved among members of the alumnae. Her pupils long remembered the way that she used the word "honor." Sister Margaret Clare retired a few years before her death due to health problems. She died of complications of illness at the age of eighty-three on September 15, 1921, and is buried with her sisters at Green Ridge Cemetery. She did, however, pass away at Kemper Hall.

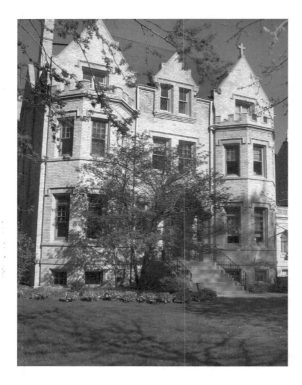

Ambrose Hall, at one time "the Convent."

Another story is told of a young student who allegedly threw herself down the spiral staircase. It was rumored that she did this because she was lovesick after being forced to leave her new boyfriend back home.

Yet another tale is told, in which a young nun committed suicide by jumping off the rocks into the icy waters of Lake Michigan. This version is the one that actually turned out to be true.

According to *Kenosha Evening News*, on January 2, 1900, Sister Augusta of Chicago was attending an annual retreat at Kemper Hall in Kenosha. When she was absent from the six o'clock service, the other sisters began to search for her. They searched the entire property, inside and out, and it was discovered that her veil and cloak were gone. The only things she left behind were her handbag, cross and other insignia of the sisterhood. The lakeshore was thoroughly searched, but no footprints could be found near the lake in the freshly fallen snow. The sisters couldn't find her anywhere.

Then, on January 5, a letter arrived at Kemper Hall addressed to Sister Augusta. The sister superior opened and read the contents. It became apparent that Sister Augusta had been planning on leaving

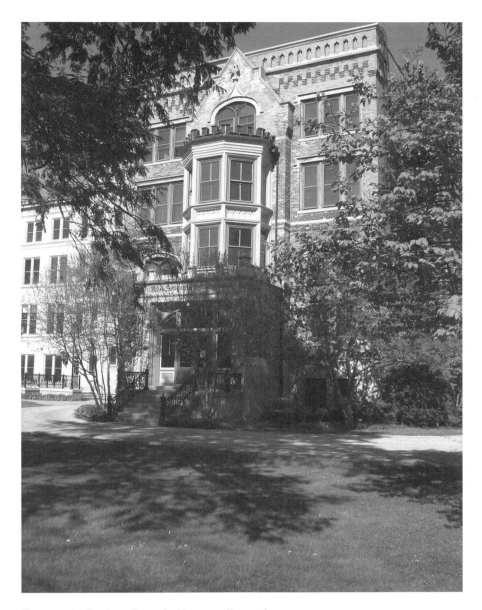

Simmons Auditorium, formerly Simmons Gymnasium.

the sisterhood and had made plans to go to St. Louis to live with a friend. Three days later, the mystery was solved as the body of Sister Augusta was retrieved from Lake Michigan, near the summer homes that no longer exist today. Two children walking with their mother on the beach spotted something in the water and immediately notified the officials at Kemper. The sisters, confused and shaken, made their way down to the beach to identify her remains. Her body was badly beaten by the rocks, ice and waves. The next day, the sisters made public the letter that they had received the day after Sister Augusta had disappeared.

On January 9, when classes resumed, sadness and gloom filled the air at Kemper Hall. There was a private ceremony held at the chapel for Augusta Pauline Henderson. Afterward, she was carried home to St. Louis, and buried next to her mother. The coroner's jury ruled the death a suicide. An inquisition produced testimony that she had been depressed and nervous before her disappearance. Apparently, her work with the poor in Chicago had taken its toll on her. She had requested time off to go home and rest. Her request had been granted, and in a few days' time, she would have been on her way home.

A few of the remaining nuns who had lived at Kemper did not remember hearing that story. They did, however, mention a history of depression within some of the sisters at Kemper Hall. Their work, especially with the orphans, would sometimes take a toll on their mental health. They were, after all, only human. Perhaps they didn't speak of the tragedy because it was too sad. It was not something that was especially enlightening conversation. The sisters may not have spoken of it, but the staff definitely did. And that is most likely how the story survived.

Could it be that it was Sister Augusta who was seen by a Kemper bakery employee back in the 1930s? On October 29, 1995, *Kenosha News* writer Don Jensen interviewed a woman who shared this experience with him. One rainy afternoon, the young female bakery employee was passing a staircase at Kemper Center when she heard the sound of footsteps on the stairs. She looked up to see a delicate white hand that was attached to a female wearing a brown skirt and the same color shoes. At first, the young baker stood frozen. Then she fled to the safety of the kitchen. Visibly shaken, she returned with others and told them what she had seen. They searched for the woman, but she was not to be found.

Perhaps it was also she who spoke to a tourist one afternoon. On October 26, 2003, another *Kenosha News* writer, Bill Robbins, interviewed a witness who had been taking a tour of Kemper one day. The man was with a larger group of tour takers. As the tour moved past the area where the staircase is located, the man lingered behind for a bit. For some reason, he felt compelled to look up toward the top of the staircase. When he did, he saw someone who looked like a nun leaning over the rail and looking back at him. She was wearing a habit with a huge winged veil. The ghostly figure made the man shudder, and his heart started racing. He tried to shake it off, and wondered if his mind was playing tricks on him. As he looked up a second time, she spoke to him. "I've been waiting for you," she said in a soft voice. As he turned to leave, he couldn't resist the urge to look up again. She seemed to be smiling at him and gave a little wave. He then made a fast exit from the area. By the time he caught up with the rest of his group, he was visibly shaken and sweating profusely.

According to one Kenosha County employee, the disturbances began soon after the county acquired the property. A young caretaker was hired to live on the premises and look after the property. Apparently, up on the third floor of Ambrose Hall (the former convent), there was a room where geranium clippings were being started for the grounds. The caretaker and his dog went up to the room to water the cuttings. While up there, the dog started growling. As the caretaker turned around to look, the door slammed shut with a *wham*! He remembered, "That really freaked me out."

And there's more. One retired English teacher, who was at one time involved with the Lakeside Players in Kenosha, shared some true stories that he had relating to Kemper Hall. The Lakeside Players, a local theater group, were invited to use the Simmons Auditorium for their productions. The group was allowed to store things upstairs, and they had some dressing rooms and a green room in the basement. The old bowling alley downstairs was then used as a set construction area.

The retired teacher—now a writer, among other things—was directing a production and had shown up early to work out some pre-rehearsal details. As he sat at a table in the middle of the auditorium, he was surprised to hear the sound of voices whispering rather loudly. He was not able to make out what the voices were saying exactly, though it sounded like a two-person conversation coming from the

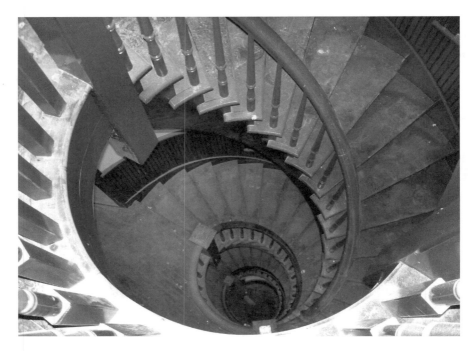

The infamous spiral staircase.

area of the front entrance. Because kids were constantly trying to sneak into the building, he was almost positive that the voices must be those of teenagers. As he headed toward the entrance, the noises stopped. He threw the doors open to find nobody, so he shrugged the incident off and blamed it on the wind. Resuming his work, he heard the same kind of whispering again, this time from the other doors at the rear of the building. Flinging open the doors, he again found nobody there. After that, he said that he went back and forth for another half hour trying to find the source of those voices.

Back then, two members of the theater group, husband and wife, were alone at the auditorium. The wife was up on the stage working and the husband was down in the basement working on a set design. The husband was disrupted from his work as he began to hear what sounded like a woman (or a young girl) screaming from down the hall. It didn't subside, either, as the screaming became louder and sounded as if it were getting closer. The grown man became extremely frightened and ran. In a huge hurry, he arrived upstairs in the auditorium and

asked his wife if she had heard anyone screaming. She replied that she had not. Reportedly, they became spooked and left after that.

Once in a while, people have "surprise" guests appear in their photographs taken at Kemper. The interesting architecture of the buildings at Kemper is a favorite among photographers. More than once, a ghostly nun or some other unusual face has appeared in photographs of the windows of Kemper Center. At other times, an unexpected figure has appeared in professional wedding photos, giving the happy couples a little "something extra" on their special day.

Apparently, nuns aren't the only spirits lurking in the shadows at Kemper Hall. A 1974 graduate whom I spoke with reminisced, "One of the other things we heard was that girls would feel something brush past their legs, like an animal would. The sisters always had a dog in the convent [Ambrose Hall] and the dog was free to roam all the buildings, since they were all connected. The dogs were buried on the grounds. If you walk through the archway toward the lake, the dogs were buried in the grassy alcove to the left."

Another Kemper employee was once so adversely affected by seeing an apparition that he had to take a few days off from work to recuperate. While on a break one day, he had wandered up the spiral staircase to have a look around. He paused, gazing out of the west-facing window in the dormitories. Suddenly, this employee was aware that he was not alone. The young man felt as if someone was standing behind him. He swung around and saw a young girl standing inside the doorway. The worker walked toward the girl and began to tell her that she shouldn't be up there. As he advanced, she ran. As the little girl turned, she went through part of the door! He followed her down to the end of the hallway. When she reached the little red door through which he had just entered, she disappeared. He was further disturbed to find that door locked tight! Having had enough, he hurried back up the hall to find another way downstairs. Eventually, he found his supervisor. The supervisor seemed amused as he asked whether the employee had just seen a ghost.

Not everyone associated with Kemper believes the place to be haunted. The aforementioned news article by Don Jensen quoted a man who had been a neighbor and at one time a caretaker. He believed that the ghost stories were made up after the school's closing. Security guards may have started circulating the stories to discourage would-be vandals and trespassers.

Night view of Kemper Hall.

The observatory tower.

A 1972 Kemper Hall graduate insisted that the stories were very old:

> *There were ghost stories there when I came—the one about the nun falling/jumping from the rocks to the lake is not at all new—it was an old story when I was there. There was a story about a nun ghost that wandered the hallways in the dorms and up the spiral staircase to the observatory. These stories were not started to keep out vandals—they were already going many years before the school closed.*

Another former student remembered clearly,

> *We always liked to go up in "the tower" at night (which, of course, we weren't supposed to do) and it was generally accepted that there were "spirits" roaming around. I remember lots of spooky stuff happening while I was there but I was also thirteen or fourteen at the time! At the same time, I have to say, it's not like we were "afraid" of anyone or anything—just more like aware.*

She paused and then added, "I remember it as a great place, and lots of fun, believe it or not."

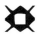

# THE CEMETERY PHANTOM

Charles Durkee owned sizable tracts of land all over the south side of Kenosha. After his wife Catharine's untimely death in August 1938, Mr. Durkee donated several acres of the land surrounding his wife's grave to be designated as a cemetery. At one point, the cemetery was known as the City Cemetery, but today it is known as Green Ridge Cemetery. Catharine was the first person that is *recorded* to have been buried there, although earlier, unrecorded graves are now suspected.

In 1906, the Kenosha Cemetery Association was formed, and its first task was to organize and beautify the burial grounds. A plotted

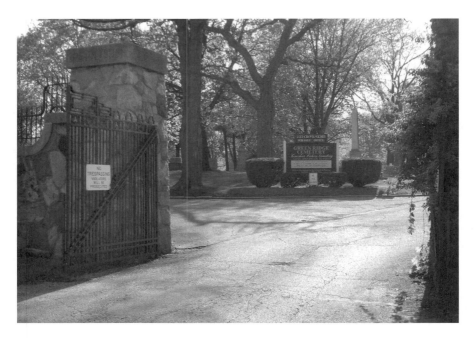

Green Ridge Cemetery, formerly City Cemetery.

map was painstakingly recorded with all of the burial information available and the purchases of lots recorded.

In 1907, the Kenosha Cemetery Association decided to construct a rock retaining wall and enclose the entire grounds with an iron fence. This fence would end up being almost 2,500 linear feet in circumference. The retaining wall was ultimately constructed out of glacial boulders, which were in great abundance in this county. The cottage and chapel (no longer existing) were also built of the same beautiful stones.

Green Ridge is by far the oldest and, together with adjacent Saint James Cemetery, the largest cemetery in the county. There are all sorts of strange stories associated with this picturesque, historical resting place. To wander the entire property would take quite a bit of time. Many of Kenosha's most prominent citizens are buried and entombed here, along with generations of citizens from probably every walk of life.

Unfortunately, our beloved city's oldest cemetery has been no stranger to vandals. In 2006, a group of young, vile vandals caused

nearly $100,000 in damage to several irreplaceable markers. This senseless damage is still visible today.

There are certain bizarre stories that people have relating to this cemetery. A woman told of how when she and her friends were teenagers, they would throw stones over the wall, only to have them thrown back at them. She swore that nobody was in the cemetery at the time. The youths witnessed this happening on a few occasions over the years.

There is also reportedly a phantom that has shown itself in broad daylight at the cemetery. One woman who has since moved from Kenosha had just moved into the neighborhood when, one pleasant afternoon, she decided to take a walk through the picturesque, peaceful grounds of Green Ridge with her family. They didn't end up staying long because her middle daughter, who was six years old at the time, suddenly became frightened and inconsolable. She told her mother that she had seen a man in a suit standing near them. Unexpectedly, the phantom man had opened up his mouth, only to have "black stuff"

Durkee family grave sites. Starting from left are the graves of Harvey and Charles Jr. (young children of Charles and Caroline), Charles, Catharine and Caroline Durkee.

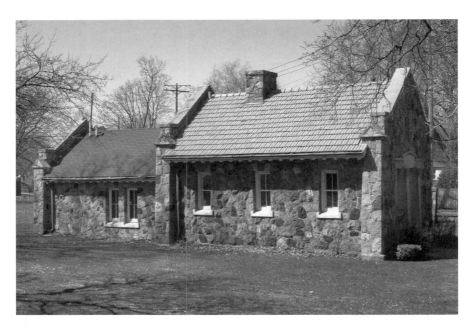

The cottage at Green Ridge, used by the cemetery as an office.

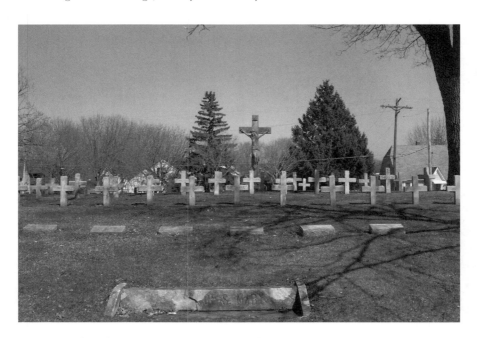

Burial sites of the Sisters of St. Mary, the sisters of Kemper Hall.

# Ghosts

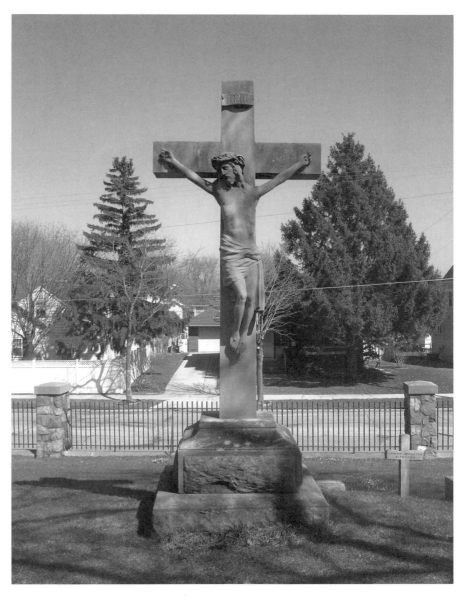

Sisters of St. Mary crucifix.

come out. The girl was scared half to death, so they left. Neither the woman nor her other children had seen the scary man.

One lifetime Kenosha resident (a former Paris firefighter) was accompanying his friend, who is a Kenosha police officer, one summer night on a ride-a-long. Part of this officer's patrol at that time included Green Ridge Cemetery. There had been some serious vandalism incidents prior to this, so police were keeping a close eye on the properties at night. The two were making their rounds that July night through the blackness of the cemetery when the subject of ghosts came up in their conversation. One told the other a legend about the cemetery. He said that if you knock on the Jeffery mausoleum wall, someone can be heard whispering, "What are you doing?" When they came up to the area of this mausoleum, the first man got out of the patrol car and decided to test the legend. Although nothing happened, he didn't stay long. He feared that his friend might drive off and leave him there alone, perhaps as a joke. This cemetery is extremely dark and unsettling at night.

At some point after returning to the patrol car, the two men spotted an American flag lying on the ground, partially submerged in a puddle of water. Being patriotic souls, they felt that our flag should not be touching the ground in this way. Carefully, the former firefighter picked up the flag and rolled it up, placing it next to him on the seat in the patrol car. Their intentions were to return the flag to Green Ridge personnel first thing in the morning.

For whatever reason, they were called away and at some point ended up getting out of the car. When they returned to the vehicle, they found that the police radio calls were now broadcasting from the PA system and could clearly be heard from outside the car. This was very strange indeed, because no one could've entered that car except for the officer; the former firefighter couldn't have even if he wanted to. As they opened up the car doors, they were both shocked and unnerved to see that the American flag had been unrolled and was propped up in the passenger's seat of the patrol car.

Not knowing what to make of this, they decided that it might be best if they returned the flag exactly where they had found it, which they did right away. They then made another trip through the grounds to make sure that all was in order. To their surprise, when they came back upon the area where they had left the flag, it had disappeared!

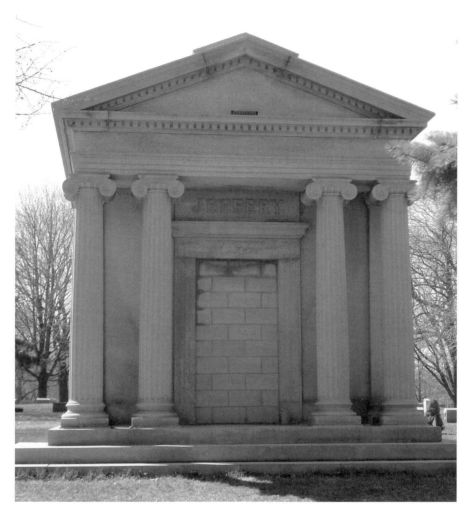

The Jeffery Mausoleum.

The next year, the former firefighter again accompanied his buddy on patrol one evening in July. They were making their rounds in Green Ridge when they observed what at first looked like someone in dark clothing running swiftly through the cemetery at a fast rate of speed. They were in pursuit of the trespasser when the dark figure suddenly leaped over a few tombstones. The distance between these stones was so great that the officer exclaimed, "That isn't human, and I can't arrest it. We're getting out of here!"

# THE GHOSTS OF THE RHODE OPERA HOUSE

While perusing old newspaper articles about Kemper Hall, something else caught my eye from the sidelines. The advertisements for Rhode Opera House are a reminder of what it must have been like to catch a performance there, way back in its heyday.

Located just east of Sixth Avenue, on Fifty-sixth Street, the Rhode Opera House is a fond memory of days gone by. The theater itself is a part of the Rhode Center for the Arts, owned by Lakeside Players, Inc. This historical theater is notoriously haunted by several ghosts that have been seen, heard and felt many times by members of the theater group that own it, as well as guests.

Peter Rhode Sr. was born and raised in Germany. Sometime about 1873, he married Mary Junker, and they moved to the United States. The family lived briefly in Milwaukee and Oshkosh, Wisconsin, and Chicago, Illinois. In 1883, the Rhode family settled permanently in Kenosha.

Rhode purchased and operated the old City Hotel for several years, beginning about 1886. Then, in 1890, he bought lots 164 and 168 on Market Street (present-day Fifty-sixth Street). On these lots, he erected "one of the best [theaters] in the state," the Rhode Opera House. In 1896, a devastating fire consumed the original Rhode, and it was quickly rebuilt at the same location.

Joseph G. Rhode, son of Peter Rhode Sr., was born in Milwaukee on September 22, 1874. He was the first of the three Rhode children, and was followed by Anna (Cummings) and Peter Jr. Joseph, well trained in business by his father, became the assistant manager of the Rhode at the age of sixteen. Young Rhode ran and operated one of the most attractive theaters between Chicago and Milwaukee for the next twenty-six years. His policy was to strive for the best in quality entertainment for guests of his theater, which at that time had a seating capacity of one thousand persons. Many famous acts graced the stage at the Rhode, as did silent movies. Competition inevitably took its toll

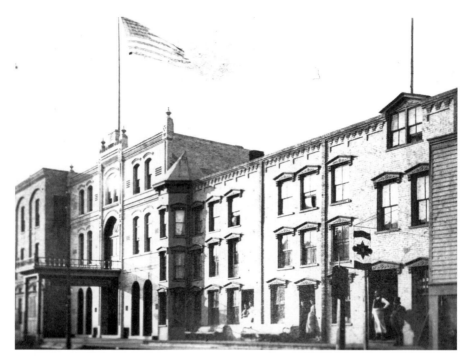

The original Rhode Opera House, which burned down in 1896, was rebuilt on the same location. *Courtesy of the Kenosha County Historical Society.*

on the family business, and the Rhode building was sold to the Saxe Amusement Company in 1926.

The second building soon met with the wrecking ball, and a brand-new theater was built. The Gateway opened with a grand celebration in December 1927. This was right about the same time when "talking pictures" became popular. The Gateway boasted a brand-new $50,000 organ and the lovely Pearlman crystal chandeliers that still adorn the lobby. The new theater had a seating capacity of 1,250, and tickets were $0.30 each.

Almost four decades later, in 1963, Standard Theaters leased the building and renamed it Lake Theater. It was then that new "red rocker" seats were installed; they are still there today. In 1976, the theater was split into two sections and the balcony seating was removed to make room for the projection facilities. The newer seating capacity was only 420 seats in each auditorium. Today, these auditoriums are often referred to as East and West Auditoriums.

Lake Theater closed in 1984. In 1986, Esseness Theater, successor to Standard Theaters, surrendered all remaining interest in the lease, which reverted back to the Rhode family trust. The Rhode family trust decided to gift the theater to a worthy organization. The next year, in 1987, the Lakeside Players, a local nonprofit theater group, moved into the building. They then renamed their new home Rhode Opera House, in honor of the Rhode family. In September 1989, Lakeside Players, Inc., purchased the Rhode Opera House for the cost of improvements. They have occupied it ever since.

Nobody knows for sure exactly why the theater is haunted. Perhaps it was the fire in the original building that sparked one child to have an odd encounter there. The youngster reported that while attending one of the children's workshops, he had repeatedly seen a fireman hanging around in the backstage area. He observed that nobody else around him seemed to be able to see the fireman.

Or perhaps actors and actresses from the past have come back to visit a favorite venue. One of the ghosts of the Rhode is that of a woman who makes her presence known in the powder room. In the ladies' lounge, located on the west side of the lobby, there is an old piano. This piano has been heard playing all by itself at times. Other times, there is a sweet, perfume-like smell drifting out of the ladies' room. Guests have asked workers what kind of air freshener they use, remarking that the scent is lovely. The volunteers were clueless as to what the smell might be, as they had used none.

A Kenosha woman had always enjoyed attending the Lakeside Players' productions. She and a female friend attended a play and used the restroom during a show one evening. After washing her hands in the lavatory, she paused in the darkened, mirrored lounge to check her hair and makeup. As she paused at one of the mirrors, she was startled to see the face of a woman directly behind her in the reflection! She quickly spun around, thinking that it must be her friend with whom she had come; a stranger wouldn't usually come up so close behind a person like that. To her surprise, there was nobody else in the lounge, and her friend was still in the lavatory. It had all happened so fast that she now has a hard time describing it in detail. She remembers that it was definitely a woman's face, and it was peering right over her shoulder. She also added that this spectral lady must have been about the same height as herself, which is five feet, two inches tall.

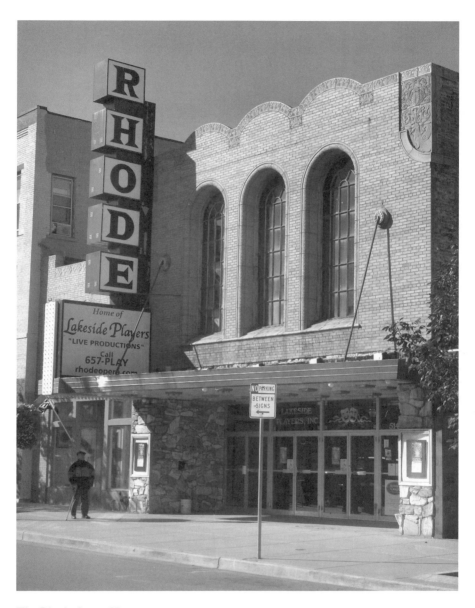

The Rhode Opera House.

Some years ago, the group held a production of *Post Mortem*, which contained a séance scene. During that scene, the sounds of a piano playing, people talking and sudden laughter filled the auditorium. The actors on stage, knowing that this wasn't a part of the prerecorded sounds that they used, played along anyway. Many play-goers weren't aware that the sounds were not a planned part of the production. Later, the attendant who had been working in the lobby that night reported that at that time, nobody was out in the lobby and the piano sound did not come from the area of the ladies' lounge, either. The whole scene was reportedly witnessed by many people and captured on videotape that night. The "extra" sounds were said to be clearly audible on that tape.

In the basement of the Rhode, something more sinister is said to make an appearance from time to time. A dark, foreboding presence has surprised more than one member in an area in the cellar that has been named the "prop area." One actress confided that when this happens, the best thing to do is to leave the area and come back at a later time. "You just get the feeling that it doesn't want company, and so I always respect its space." She would later return to find the entity gone, and she would go on about her business as usual.

One story is told of a female volunteer who tried to enter the furnace room, which is located deep in the bowels of the basement. She found that she couldn't get the door open because a heavy wooden chair had been placed a few inches in front of the door. Finally, she was able to push the chair out of the way, thinking that someone must have purposefully placed the chair there for some reason. When she entered the room, she was dumbfounded to see that this doorway was the only entrance to the furnace room! This scenario happened to her more than once. Each time, she would push the chair way across the room, only to have it back in front of the door, blocking the entrance again, the next time she would enter the room.

Backstage at the theater, there is a series of hallways and dressing rooms. There is also a larger room that holds most of the costumes. Most of the group says that there is something malevolent that is often sensed in this area. It seems as if no one likes going in there by themselves. One night, a group of ghost hunters were taking a tour through the building when one of the tour takers was actually scratched on the face by an unseen force.

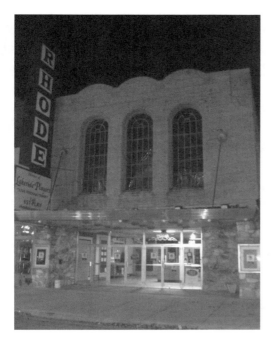

Night scene at the Rhode Opera House.

Of the two theaters, the ghosts seem to prefer the East Auditorium, which is the live performance theater, while the West Auditorium is specifically set up to show moving pictures. Many times, actors and actresses who were rehearsing have seen a man sitting in one of the seats near the back of the auditorium. When they looked back again, he was gone. One time a woman in the group sat in that area to watch a rehearsal. A man walked by her and told her, "That's the ghost's seat." Neither she nor anyone else in the group was able to identify who it could have been, nor did she ever see him again.

Another night, a volunteer stayed behind to vacuum near the foot of the stage. Knowing that she was alone, she was quite surprised to see movement in the back of the auditorium. There she saw a translucent man moving up the row of seats, touching the back of each seat as he traveled toward the aisle. This specter was moving quite rapidly, as if he was in a hurry. The figure vanished from sight as he neared the aisle, and left a stunned volunteer to finish her chore.

At any rate, the Lakeside Players seem to be at peace with the spirits that roam the theater. Only time will tell who will be the next to run into the ghosts of Rhode Opera House.

# THE GENTLEMAN WEARS BLUE

Just around the corner from the Rhode Opera House is a pub named Brat Stop Too. It is a sister restaurant to the legendary Brat Stop in Kenosha, Wisconsin. Both locations are owned by Gerald S. Rasmussen, who opened the original Brat Stop on April 15, 1961. Although many of the same tasty menu items are served at either location, Brat Stop Too has something the original Brat Stop doesn't—a resident ghost.

Located on Sixth Avenue in downtown Kenosha, the Brat Stop Too is actually made up of two separate buildings. The northern half was built in 1916, and the southern half was erected later, in 1927. Originally, the southern half of the tavern was built by the Saxe Company when the Gateway (now the Rhode Opera House) was constructed. The southern structure was built to be used as an alternate, or "gentlemen's," entrance/exit to the Gateway Theater via Sixth Avenue. Evidence supporting this is apparent if one studies the façades of the two establishments. The southern half of Brat Stop Too has a façade that does not match the northern half. It does, however, match that of the Rhode Opera House, exactly.

Over the years, the two buildings were used for many purposes such as stores, restaurants and taverns. We know that in 1940, it was known as the Gateway Tavern. In 1950, it was Harry Gordon Tavern. Fechner's Tavern called it home in 1963, and in 1970, it was known as Bill & Mike's Bar. More recently, it was known as Hollywood Spirits, and before that it was called the 6th Avenue Deli. In 1990, when Mr. Rasmussen purchased the properties, he had the two sides joined together to make one spacious tavern and eatery. The buildings still have separate basements.

Employees say that in the southern basement, things can be rather creepy, because some have seen a man in a blue work shirt lurking down there. This basement is long and narrow and sports an unusually high ceiling. This underground space is sectioned off into narrow,

# Ghosts

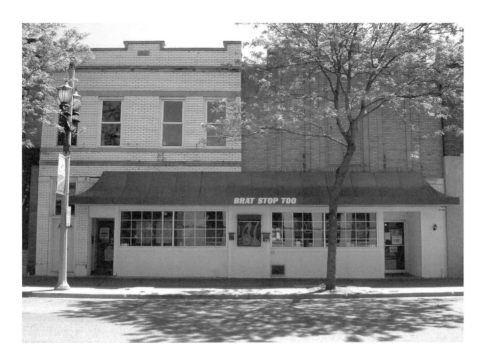

*Above*: Brat Stop Too.

*Left*: A close-up of the matching decorative façades.

seemingly endless corridors that twist and turn. One makes a turn and has no preview as to what lies in wait just around the corner. Many of the bartenders have reported hearing unexplained noises from within the basement. There are reports of doors being slammed and of loud banging sounds. One of the former male employees stated, "You could always feel *something*, whenever you had to go down there."

That same employee was there one morning, mopping the floor in the women's bathroom. He propped the door open with a wedge and went on with his work. As he turned to leave, he saw that the door had somehow been closed. This man thought the situation was particularly odd, as he had not heard the door close. He questioned other employees to find out whether any of them had closed him into the ladies' room. The others swore that they had not.

Another time, one of the female workers was standing at the top of the stairway sweeping the floor after lunch one afternoon. When she happened to look down the stairs, she was startled to see a man standing at the bottom, looking back up at her! She shuddered as she described what happened next. The apparition took one step back and disappeared into the basement wall (which is solid and made of cinder blocks).

Yet another employee, a maintenance man, went into the basement to retrieve something. He gasped as he spotted the apparition of a man darting around the room, as if he were scared and looking for a place to hide. This episode went on for only a few seconds until the man disappeared without a trace. After that, when the maintenance man went down into the basement, he would announce himself, saying loudly, "I don't mean any harm or disrespect…"

Apparently, the spirit of the man is not limited only to the basement, and he doesn't seem to like the employees leaving the establishment unattended, either. Before opening for lunch one morning, a manager went downstairs to fill ice bins out of the ice machine in the basement. He filled his containers, hauled the ice upstairs and started toward the bar area. While passing, he casually glanced over to the south end. There, sitting at a table on the south wall with his legs crossed, was a man wearing blue. The manager remembered clearly, "He appeared to be smoking a cigarette and was just kind of sitting there watching me." Surprised, the manager set the ice down. When he looked back again, the ethereal gentleman was gone.

A young bartender was working alone at night when she saw "a guy in a fedora hat that walked right through the wall in the basement." She reportedly was so scared that she almost "wet" herself.

Another female bartender has seen the apparition on occasion. Once, she was wiping the bar and stocking the inventory when she saw the figure standing in a corner. "He always has a blue shirt," she stated. She also added that she has taken to singing loudly when she enters the basement. This strange ritual obviously is some attempt to ward off the spirit. Sometimes, she swears that something touches her hair as well. This poor bartender, who works the night shift, is scared half to death of that ghost. As we talked about it in the brief interview, she seemed to become visibly disturbed by our discussion. "Great, now tonight I'm going to have the creeps," she said, as she laughed nervously and shuddered.

# Vaj's Garage

Vaj's Garage Restaurant & Filling Station is a great place to be if you happen to find yourself in Bristol, Wisconsin. One of the first things you will notice as you approach the entrance is a wooden sign overhead, on which is crudely written "DISMUSBEDABAR." This must be the bar, indeed, because it was, in fact, the very tavern/eatery that I was hoping to find on Highway 45, about a half mile south of county road C. Some years ago, this bar was called G.L. Spirits, and it was well known in these parts as being haunted by a poltergeist.

Once inside, there is a long wooden bar, tables and booths with checkered tablecloths and hubcaps hanging from the ceiling, along with alcohol signs. It also becomes apparent that somebody here was a woodcarver. There are hand-carved wooden pieces everywhere that range from humorous signs to intricately carved, inverted half-barrels that cover the light fixtures on the ceiling. The east walls are made up

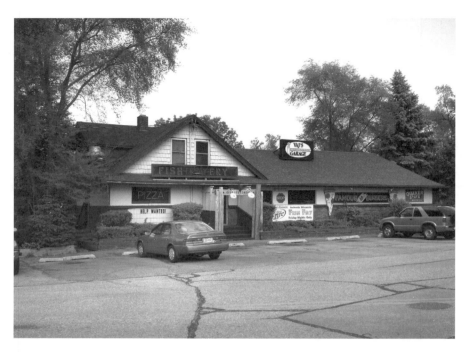

Vaj's Garage Restaurant & Filling Station, formerly Lake Side Tavern and G.L. Spirits.

mostly of large windows, all facing beautiful Lake George. From the bar, a person can gaze out the windows and see two volleyball courts, each with its own wooden scoreboard, which are accessible by rustic-looking ladders. Also outside, there are horseshoe pits and a few picnic tables. Beyond these, straight ahead, is the edge of Lake George. A narrow, jagged channel jets inland from the lake, coming to an abrupt end in the reeds at the rear of Vaj's Garage.

Poltergeist, which means "noisy ghost," is a word of German derivation. This is the kind of ghost that locals believe haunt the tavern. There is an area described as an apartment upstairs on the north end of the wooden structure. Although it is not rented out anymore, many residents, employees and bar patrons have reported hearing the loud, creaking footsteps of someone unseen on the stairway that leads up to the apartment. Plenty of the apartment's dwellers have heard footsteps pacing the hallways in the middle of the night as well.

It all started as early as 1971, they say, when Joe and Carol Goschy ran the tavern from then until 1974. They talked of hearing strange

footsteps on the staircase late at night, as if someone kept getting up to go use the restroom. Next, Tom and Fran Webb, who ran the tavern from 1974 to 1978, reported hearing the sounds of someone walking the stairs at all hours of the night. Employees heard it. Patrons heard it. One longtime patron even chased after it once. I interviewed a gentleman who said that he and the bar manager were sitting at the bar watching television one night. They kept hearing someone walking up the stairs, even though there was not a single other person around. After the third time they heard it, the bar manager said to him, "If you hear it again, go after it." Not long after, they heard the sounds once again, so the bar patron opened the door and flew up the stairs and into the darkness. When he reached the top of the stairs, he made a turn and was walking through a hallway when he suddenly felt a cold breeze go right through him.

On another occasion, he and an employee were again at the bar when they witnessed an ashtray slowly slide a distance of a few feet down the counter. Each felt relieved that the other had been there, because there were then two witnesses to the incident, and that meant that neither man was imagining things.

The resident ghost is not limited only to the upstairs area. Several people have had experiences in the bar as well. Once, an antique rifle flew off the wall and traveled a few feet, for no apparent reason, in front of several witnesses. Another time, a hubcap flew off the wall, again just out of the blue. A customer saw a bar stool tip over with no one around to push it. Bags of potato chips on a rack started flying one time, and another time, workers found potato chips strewn across the floor after they had swept up for the night. Sometimes the air conditioner would turn off and on randomly, with no one having touched it. Witnesses insist that they can hear someone walking around upstairs, although the apartment is no longer rented, and that once in a while the sound of glass breaking can be heard from behind the bar, although there is no broken glass anywhere to be found. There are also many reports of doors having opened and closed without anyone having entered or exited. The jukebox, it seems, also has a mind of its own.

Although most of the employees don't seem to mind the ghost hanging around, one bartender is said to have quit her job soon after seeing what was described as a blurry figure one night. As she was on one end of the bar near the cash register, she was startled

to see another woman behind the bar with her, looking back at her. This apparition is described as being "a face and half of a body." It is said that she didn't finish her closing duties that night before exiting the tavern.

Prior to that, a bar manager who lived in the apartment upstairs had just settled into bed after work one night. Earlier that night, he had turned off all of the lights and closed up the bar. Suddenly, he heard music coming from downstairs, and when he came back down to check, the lights were all turned on, the jukebox was playing and the doors were unlocked. On the floor was a giant trail of drinking straws that had been arranged end to end. No doubt the man was dumbfounded, as he was certain that he had closed and locked up for the night.

Gary Wier has owned the pub since 1989, and at one time he named it G.L. Spirits, after George Lake. The employees ended up naming the ghost "George" too, and even made him the team mascot. Although loud, naughty ghosts can be a real pain, no one seems to claim that this ghost is particularly menacing or scary. There was another reason why they called him George, and that is yet another page in the whole story of Vaj's Garage.

The bar's original owners were George and Florence Leisemann. They operated the Lake Side Tavern (as it was then called) from 1935 to 1943. The building is believed to have been constructed from some materials that were recycled from a cheese factory in nearby Woodworth. The Woodworth Farmer's Creamery Company building was constructed in 1915 and was torn down during the years of the Great Depression. Farmers bought shares in this business and constructed a cheese factory to rival the Renz Factory, also in Woodworth. It was only in business for a short time, however, as farmers were told that they had to leave their cheese for one year for aging. When they returned, their cheese was gone and so was their money. Later, the building was also used as a boardinghouse for workers who were paving Highway 50.

At one time, Lakeside Tavern was divided into two sides, with the tavern being separate from a cheese market. At some point, this bar was moved from its original location at the southeast corner of Highway C and Highway 45 (about a half mile up the road).

Florence Leisemann was known to have suffered from a great many health problems later in her life. She also had a miserable

childhood. It is said that her mother would lock her in a closet with only her potty chair so she could leave the young child alone and go off on "excursions." Her father wasn't much of a help to the little girl, as he was known to be a cold and distant man. Her parents divorced when she was a teenager, and Florence then went to live with an aunt. George, who became her husband, was similar in some ways to her father. They managed the bar, the cheese market and the farm. They also lived in the apartment upstairs. Florence first became ill in 1941, and by 1951, she had had a cancerous breast removed. She died on November 30, 1959, possibly in an institution. George later remarried.

In the past, the tavern has attracted some media attention because of its ghost stories. At least two psychic investigators have visited in decades past and relayed to the owners that there is a ghost present, and that she was female, not male. Could it be possible that her name is Florence? These days, most people seem to think so.

Today, the tavern is still home to the "ten-ounce burger," and the ghost stories still circulate. The pub was renamed Vaj's Garage about fifteen years ago, in honor of Mr. Wier's father. I am told that "Vaj," when translated from Polish to English, means "Walter." When I asked, I was told that it was he who was the woodcarver. On a westward-facing wall is a framed glass case where Gary Wier proudly displays newspaper articles that have been written about his friendly but rambunctious ghost. Reportedly, all has been quiet for the last five years or so.

# The Edgewater

"There were about five of us who saw it, and it was during the day... we weren't open yet," he said to me. This man and some of his friends were all sitting at the bar in the Edgewater one day, shooting the breeze, when all at once, they saw something. He had a hard time describing it, at first. What they saw, apparently, was some sort of an apparition, light in color, without a defining shape. Whatever it was, it stood there

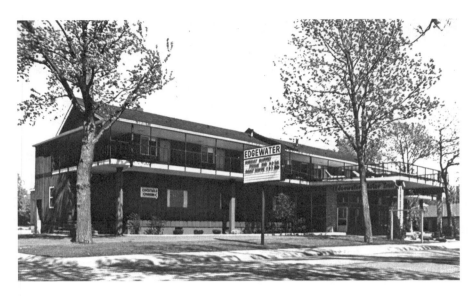

The Edgewater Resort, circa 1960s. *Courtesy of Robert LaTessa.*

long enough for everyone to notice, after which it vanished. Whatever it was, it was *something*.

Although this was the only reported sighting of such a thing, he had the sneaking suspicion that he was not alone in the building at night. The large structure could be pretty unsettling when nobody else was around. He stated that the idea of having someone else around was more of a comfort than a scary experience—like the one time when the ghost woke him up in the middle of the night.

"I can't really tell you how, but he [for some reason, he always felt it was a he] woke me up out of a sound sleep. I got out of bed and looked outside toward the entrance, and caught some young men stealing all of my booze—right out of the front door! The police were called, and the thieves were caught in the act, but I never received my alcohol, or my pourers back," he joked. That there was someone else there he was certain, and he wondered if the reasons why may have had something to do with that old icehouse in back.

The Village of Twin Lakes, incorporated in 1837, is located east of U.S. Highway 12 in western Kenosha County, not far from the Wisconsin–Illinois border. It was named after the two lakes that were located on the northern end of their settlement. It is believed that the lakes were named after a set of twins who were born about 1842, the

first set born in the area. The larger lake, Elizabeth, was named after the Queen of England. The smaller lake, Mary, was named after the Queen of Scots. Before that time, they were collectively referred to as Nippersink Lake. Together, the two lakes of Elizabeth and Mary cover over one thousand acres with water, and neither lake is deeper than thirty-three feet at any point.

The Edgewater Motor Inn was located in Twin Lakes, Wisconsin, on the northeastern shores of Lake Mary. Built in 1914, it was first known as Schwardt's Resort. The fine hotel was a long, two-story building with a dining room, bar and dance floor downstairs. It is said that the barroom was a showplace, featuring a large mahogany bar, mirrors and beautiful inlaid tile flooring. There were also cottages for rent and a beach with a long pier, wooden swings and shade trees. The resort ran a bus that would take guests to and from the railroad depot.

Over the years, the name of the resort changed many times. In 1920, this vacation spot remained a popular resort and was called Neidl's Resort, owned by Peter Neidl. Next, it was home to Bordin's Resort, owned by Sylvester Bordin. It is believed that at this time, the boat rental facilities were added.

In 1936, it was renamed yet again as Zimmermann's Beach Hotel, owned by John Gurichan, who leased it to John and Regina Zimmermann. The Zimmermanns left in the 1940s and built their own motel, so this building was then sold to Mike Kotorynski and Wally Chizewski and was renamed Edgewater Beach Hotel.

Wally Chizewski sold his half to John and Mary Bobis, and in the '50s, the couple ran a hamburger stand in front of the resort, which was known as the Red Dot. The Bobises moved on to operate a store, leaving Kotorynski all alone to run the place for many years, until he sold it to John Ulanski.

In December 1968, the building was purchased from John Ulanski by Gerald S. Rasmussen. The Edgewater Motor Inn was a full-service resort that featured hotel rooms on the second floor of the main building and in a separate, smaller building to the north. The first floor was divided into a live entertainment venue/dance floor on the south end and a supper club/cocktail lounge on the north, which was known for its prime rib dinners. In the 1970s, the Edgewater was also becoming known as a live entertainment venue, playing host to national music acts. The rock band Cheap Trick played there on December 26, 1976, and Muddy Waters took the stage twice in 1981.

In the early 1980s, Robert LaTessa agreed to "lease-to-own" the establishment from Gerald Rasmussen. The Edgewater, at that time, was almost seventy years old. Attached to the rear of the hotel was a large icehouse, left over from the days when ice was harvested each winter on these smaller, inland lakes. Also located in the basement was a telephone switchboard that at one time may have served the entire village of Twin Lakes.

Robert LaTessa, himself a musician, remodeled the building, turning the whole first floor into a nightclub featuring a dance floor on one side and live entertainment on the other. There, he presented many well-known talents such as Styx, Survivor, Queensryche and Robin Trower. The nightclub became a hot spot and drew younger crowds, especially from Illinois. The second floor was transformed into living quarters, and plans were made to open a supper club, the Over the Edge Eatery, which never ended up being officially completed. Rooms were still rented to guests in the other building, and a caretaker was hired to oversee all of the hotel operations.

This caretaker was a local guy who had long hair and rode a bicycle. Somewhat of a loner, and shunned by the community, this man came and asked for a job one day soon after the remodeling had begun. He openly admitted that he had had a troubled past, but said that he needed a job and a break. He was given the job on the spot, and this man turned out to be a hardworking employee. In fact, he hardly ever even took a day off of work.

One day, sometime later, he did finally ask to have a day off. Some friends of his were taking him to Chicago for the evening to visit some taverns. Upon arriving home that night, he must have decided to go for a late-night swim in the lake. Tragically, Edward McRoberts drowned in the lake that night, most likely right in front of the Edgewater. He was twenty-nine years old.

Business boomed in the nightclub until 1986, when the legal drinking age in the state of Wisconsin was raised from nineteen to twenty-one. After that, the number of patrons greatly diminished. The Edgewater was forced to close its doors for good soon after. The building sat vacant for a time and was eventually sold. Sadly, it was destroyed in 1989 to make room for the Edgewater Beach Condominiums. They say that the swimming pool is now in the general vicinity of where the proud Edgewater once stood.

PART II

# LEGENDS

# GHOST IN THE GRAVEYARD

It's a rather nice place, really. Saint Casimir Cemetery in Kenosha, Wisconsin, is a well-cared for, tranquil little city for the dead. A majority of the persons who are buried here were missed, and that they were loved definitely shows. So the question remains: why, then, is there reported to be a phantom "ghoul" in this place that lurks around headstones late at night? A shapeless, gray mass is sometimes seen by motorists out of the corners of their eyes while passing. And could this have anything to do with a very unfortunate, tragic event that happened long ago, out in the road near the cemetery?

The St. Casimir congregation was formally incorporated and organized on November 16, 1901, and was made up of about fifty families and a large number of single individuals, all of Polish descent. Prior to that time, this group had all been members of St. George's Parish, in Kenosha. Although they were happy enough at St. George's, the Polish parishioners longed to have a church of their own. It was decided to name the new church after Saint Casimir, the onetime prince of Poland. Prince Casimir was born on October 3, 1458, and was the second of six sons born to King Casimir IV and Queen Elizabeth, an Austrian princess. Prince Casimir is best remembered for the virtues of "justice" and "chastity" (as he preferred to remain unmarried). Pope Adrian VI canonized him in 1522, and he is the patron saint of Poland and Lithuania.

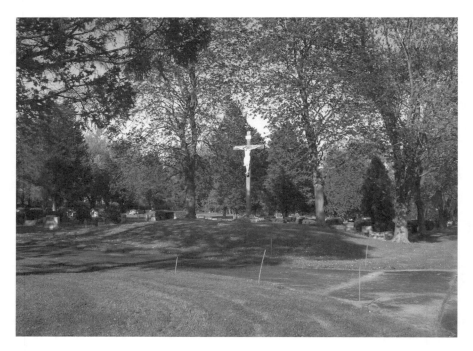

Saint Casimir Cemetery.

Building of the church began in 1901, and the cornerstone was laid on November 9, 1902, at a grand celebration that included a parade. Sometime in 1906, the church purchased land for a cemetery, located approximately two miles west on Forty-seventh Avenue. From that time until early 1931, the burial grounds reportedly sat somewhat neglected. Later, during the '30s, a fence and the chapel were built, the drive was paved, a cross was erected and the landscaping was greatly improved. For many years, a field Mass was celebrated on Memorial Day each year at the cemetery. Saint Casimir is the final resting place of ten veterans of World War I and one veteran of World War II. It is important to note, however, that not everyone who rests here is of Polish descent.

Just past the cemetery, to the north, is a short gravel road. On this road there are a few houses that face north, with their backyards butting up to the cemetery, which runs east–west. On May 17, 1968, a neighborhood boy crossed Forty-seventh Avenue to retrieve the mail. As he was running back across the street toward his house, he was hit by a car near the front of the cemetery.

# Legends

The front-page *Kenosha News* article of May 20, 1968, told the story. The driver, a twenty-three-year-old man, was in a state of shock and was unable to answer questions. After the accident, he went to the nearby Lippert home to use the phone. The driver was taken to the hospital and treated for shock.

The incident was witnessed by some of the young boy's siblings, who were outside playing at the time their brother was struck. The victim had come to Kenosha with his family from Texas in 1962 and was in the second grade at Hillcrest Elementary School. His death was pronounced at St. Catherine's Hospital.

This untimely death was devastating to this family, and for the boy's father, it was almost too much sadness to bear. His family buried him at Saint Casimir, undoubtedly to keep him closeby. The family confides that there were many nights when the father would go out and sleep by his son's grave. This child had been his namesake, his oldest son, and now he was gone. Surely it was one of the darkest hours in his life. Slowly, at first, the years passed. The father presumably stopped sleeping in the graveyard at some point.

Over forty years later, father and son were finally reunited. When the father passed away in November 2000, he was laid to rest near his son. Having been ill for some time, he undoubtedly began to reflect on his life. More than once, he made mention to family members of his favorite song. The Spanish song's title, "Los Caminos de la Vida," when translated into English roughly means "the roads of life." For this man, the verses held special meaning and the lyrics really hit home.

Sometime after his funeral, one of his daughters drove into the cemetery to visit his grave. As she pulled into St. Casimir Cemetery, "Los Caminos de la Vida" started to play on the car radio. She thought this was rather strange, hearing that song right at that exact moment. The radio station seemed to hardly ever play that song anymore.

The second time that she visited the cemetery and that particular song started playing, she became a little unnerved and quite emotional. Ultimately, she decided the incident *had* to be some strange coincidence.

But the third time it happened to her, this daughter could no longer deny that something unusual was going on. Was this some sort of message—a greeting from her father perhaps?

# THE SIMMONS LIBRARY SECRET TOMB

A few years back, while doing some research, I happened across one of the most absolutely bizarre stories about Kenosha that I think I've ever read. The original story, in its entirety, can be found in the book *Ghosts of Kenosha County*, in our own public library. According to this story, very few people were aware that when Zalmon G. Simmons and his architect, Daniel Burnham, planned the design for Simmons Library, they made provisions for a secret burial chamber.

The tomb was to be located in the cellar of the building and was to be used as a final resting place for any Simmons Library employee who wished to be buried there. As years went by, Simmons Library employees were interred there strictly on a volunteer basis. It is noted, however, that most did take advantage of the opportunity to be laid to rest in the crypt.

The very first person said to occupy this chamber was Simmons's own son, Gilbert Maurice Simmons, who had passed away of pneumonia ten years before, on January 15, 1890. In 1900, according to the legend, Simmons requested that his son's remains be exhumed from Green Ridge Cemetery and reinterred in the secret tomb that was located underneath the library. Apparently, the city accommodated his wishes, and no one was the wiser.

In February 1910, Simmons's deathbed wish was to be placed next to his son in the chamber beneath the library. It is said that these were the only two people entombed there who were not actual library employees. The legend states that library employees were sworn to absolutely secrecy, as mentioning the tomb to anyone would result in immediate dismissal.

Time passed, and then the unthinkable happened on October 31, 1935. Sometime about daybreak, a custodian was cleaning on the main level of the library when he started hearing some of the most disturbing sounds. He was shocked to hear what sounded like a woman crying

# Legends

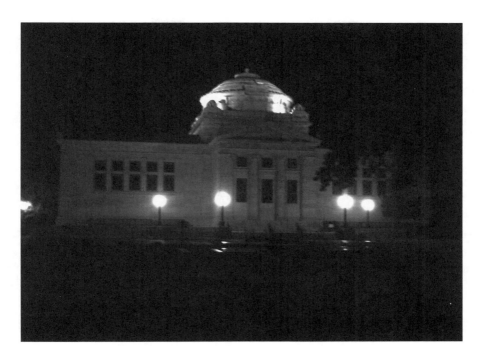

*Above*: Simmons Library at night.

*Left*: Gilbert M. Simmons, son of Zalmon Simmons. *Courtesy of the Kenosha County Historical Society.*

and begging for help. Probably because the door to this section of the basement was always kept locked, he could not, for the life of him, find the source of the strange sounds. He then called the police, who found the noise to be coming from behind a locked door to the west of the main entrance. They entered and made their way down a metal spiral staircase, and when the vault door was opened, they were shocked and horrified to find a woman standing there, half filled with madness and completely naked. They had entombed her while she was still alive! She then collapsed at the top of the stairs and died (for real, this time). They put her back in the casket, and soon after, it was decided to seal the entrance to the Simmons Library tomb forever. Somehow, legend has it that they managed to keep it all very quiet and even convinced the newspaper not to report the incident to protect the reputation and public image of the Gilbert M. Simmons Memorial Library.

# THE CRIES OF THE UNKNOWN SOULS

Out in Pleasant Prairie, near where Highway H intersects with Bain Station Road, lies a curious, forgotten little cemetery. It is so tiny that if you were driving the speed limit and happened to blink, you just may miss it entirely. This is the Kenosha County Cemetery. Only the very poor or otherwise unknown persons are buried here. The burials date from 1924 to 1972. The sign out front warns "Caution, Ground Settling." This is believed to be due to wooden coffins collapsing over time, causing the ground to sink in some spots.

This odd little cemetery is believed by many to be haunted. Rumor has it that sometimes, late at night, you can still hear the cries of the indigent souls who are buried there. Even though this writer has never actually found someone who knows this to be true, the legend lives on. Perhaps the reason for the continuing tale is the overall strangeness of the cemetery.

The earliest headstones present at the cemetery were engraved with a name and date (when known). After just a few years, these were

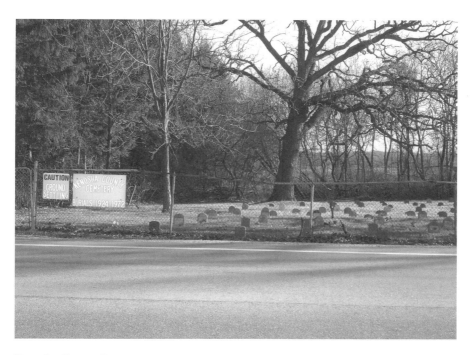

Kenosha County Cemetery.

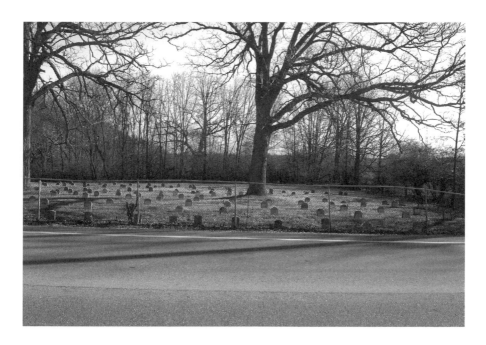

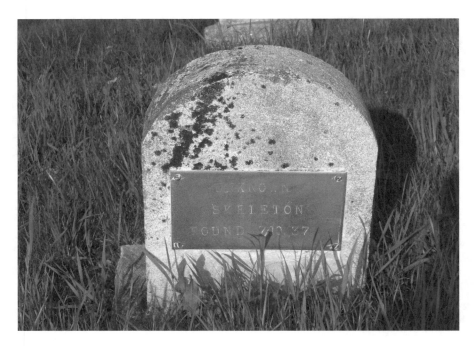

The unknown skeleton grave site.

switched to simple metal nameplates that were attached to the stones. In the southeastern corner of the cemetery, hidden under some brush, are rows of unused identical stones. A look at the burials recorded tells that there are many more graves here than one might think. Approximately 264 persons were interred at the old county graveyard. A good many of the people are recorded as being unknowns. More than a few entries indicate that they were infant burials, more often than not unnamed. One more unknown person buried in July 1937 was noted as being a skeleton.

Perhaps also lending to the general strangeness of this odd little burial ground is that it is completely unadorned. Most cemeteries have varied and interesting headstones. Most cemeteries also have flowers, wreaths and personalized objects memorializing friends and family members who are missed. None of these things can be found in Kenosha County Cemetery. Even so, the place has a certain character and distinctness all its own. The county government saw fit to bury its dead, and they still look after it to this day.

And as far as the legend, I guess you just never know…

# THE MYSTERIOUS BALL OF OAKWOOD CEMETERY

There once was a man who worked as a bartender at the Tin Cup tavern in Paris Township. He lived in Kenosha, so he often traveled home by way of Highway 31 (Green Bay Road). Very late one night, after closing the tavern, he was driving home. As was his custom, he turned east onto County Road E, as he had done many times before.

This time, however, he stopped dead in his tracks when he saw a large round object lying in the middle of the road. Upon further inspection, he started to get the feeling that the "ball" looked familiar somehow. Suddenly, he knew where he had seen this object before, as he focused his gaze on the Oakwood Cemetery. Sure enough, the large marble ball was indeed missing from the large stone monument that has been in the cemetery for well over one hundred years. It is said that the gentleman took a different route home that night and almost put it out of his mind. That is, until he found out that others had experienced the same thing on different occasions.

The monument, made of granite, is over six feet tall. The "ball" atop the monument measures almost 76¼ inches in circumference. It is so heavy that it is highly unlikely that children would be able to move this ball as a prank to unsuspecting motorists. It is also unlikely that it rolled into the road by accident, as the ground is not sloped toward the road by any noticeable degree.

The biographical history of the Burroughs family (the family to whom the monument belongs) does not offer any real clues as to why this strange event would keep occurring. One may follow their lineage from the names that are inscribed on the monument.

Stephen Burroughs was both a carpenter and a bridge builder. He arrived at the settlement of Southport in 1846 and worked as a carpenter. About 1860, he began working for the Northwestern Railroad Company, for which he was superintendent of bridges and

The Burroughs family monument. *Courtesy of Courtney Shatkins.*

buildings for over twenty years. In 1882, he purchased a 164-acre farm in Somers Township where he and his wife Susan (Newbury) raised their family. He lived on that farm until he died on March 13, 1899.

Eben Burroughs was Mr. Burrough's son and ended up being a junior partner of a very successful firm called Petersen & Burroughs (implement and machinery dealers) in Racine, Wisconsin. As a small boy, Eben lived in Kenosha until the family moved into the farm in Somers. After graduating from Racine High School, he worked on his father's farm for a few years. Eben Burroughs married Minnie (Fink) in 1894.

# WISCONSIN'S WOLFMAN

One evening in 1989, two men were coon hunting in Kenosha County. They had just walked out of a densely wooded area. Suddenly, they turned back because they began to hear what sounded like something walking near the edge of the woods. Standing there in the dark, they wondered aloud what it could be. The unseen thing then gave out a hellish growl and moved off deeper into the woods.

Although there is no accepted scientific proof that werewolf-like creatures exist, there are real, everyday people in Wisconsin who have definitely seen something out of the ordinary. Over the years, there have been hair-raising reports of up to two hundred sightings of a large, upright, wolf-like creature in southern, rural Wisconsin. And those are just the ones that we know about!

The earliest sighting happened in 1929. In the late 1980s, and continuing through the 1990s, there was a surge in reports of this most elusive beast. These were researched in depth by Linda S. Godfrey, author of *The Beast of Bray Road: Tailing Wisconsin's Werewolf* (2003). Ms. Godfrey was at that time, among other things, a researcher and journalist for a local newspaper in Elkhorn, Wisconsin. After receiving a very peculiar tip one day, she began to seek out eyewitnesses who claimed to have seen this strange canine-like monster.

Most of these reported sightings occurred in the area of Elkhorn, on or near a country road that runs between Highway 11 and County Road NN called "Bray Road." But, on Easter Sunday 1992, the elusive creature made an appearance in western Kenosha County, in a small town appropriately named New Munster.

Two neighbors simultaneously spotted the creature in a small, rural subdivision just north of Highway 50. Cornfields and marshes surrounded the secluded subdivision. It was raining outside, and both of the ladies were inside their respective houses. One of the women happened to look out her window and saw something unnatural walking across her yard. She described it as an extremely large, four-legged animal with long, dark brown fur. It darted into a wooded area and was gone.

The next morning, she and her neighbor were out taking their routine walk when her neighbor started telling the woman about this odd thing she had seen outside the day before. The women then realized that they had both been witness to the same wolf-headed

creature. Both women agreed that what they had seen was extremely large. Both remember it as being "so highly unusual," like nothing either neighbor had ever seen before or since.

More recently, the wolfman made an encore appearance in this county again in early 2006, this time in the community of Powers Lake. A man who was a professional at Mitchell International Airport in Milwaukee would travel down the same road on his way to work at 3:00 a.m. every day. On four occasions, he saw what was described as a "large, upright, wolf-like creature" along this particular road, which was close to two marshy wildlife areas. Of those, once he observed the wolfman on all fours walking across the road. This witness said that the creature's eyes were bright yellow and that its stance gave the impression that it was completely unafraid.

These published, well-read stories attracted national attention from television shows and tabloids, and eventually a movie was even made about Wisconsin's werewolf. Most recently, the wolfman was featured on the History Channel's wildly popular *MonsterQuest* series.

The producers of *MonsterQuest* administered polygraphs to four of the witnesses who volunteered. All four were found to be telling the truth on the relevant issue of whether they had seen a wolf-like creature that walked on two legs.

PART III

# BIZARRE TRUE TALES

# THE FIRST FORTUNETELLER

The *Detroit*, a steamboat, wrecked at Southport in October 1837. A twelve- by sixteen-foot wooden ladies' cabin was salvaged from the upper deck of the steamboat. This cabin was purchased by a man named William Seymour and relocated to Lot 1 in block 14 of the harbor, where it was occupied by an African American man named Joseph Hobbs. Hobbs divided the building in half. The front quarters were a barbershop and the rear quarters offered fortunetelling. It is said that he made a decent living doing this. Barbers were a necessity to some, and fortunetelling offered a form of entertainment to others.

Soon after, however, a "doctor" moved into the building. Dr. Daniel McGonegal used the other room for his botanical drugstore. His methods and concoctions are remembered as being questionable, at best. After two years, he apparently moved on when other, more conventional physicians moved into the settlement.

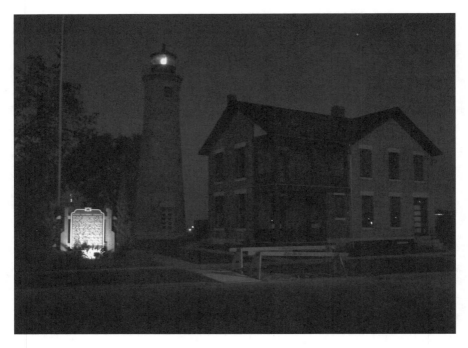

The 1866 lighthouse and keeper's dwelling.

# THE TRAGEDY OF THE SS *WISCONSIN*

On October 29, 1929, the stock market crashed, the Great Depression began and the lake steamer SS *Wisconsin* foundered off the shore of Kenosha. Crowds of horrified people watched helplessly from a bluff at the end of Seventy-fifth Street as twenty-foot waves swallowed the ship and sixteen unfortunate souls, three of whom have never been identified.

The SS *Wisconsin* was a 215-foot-long steel steamship. Built by the Goodrich Steamboat Company in 1881, the SS *Wisconsin* was one of the fanciest, most expensive and most technically advanced steamships of its day. The *Wisconsin* and its sister ship, the *Michigan*, were the first Great Lakes vessels with decks made of iron instead of wood. History tells us that the *Wisconsin* had a long and troubled life.

Two years after construction, the iron steamboats were sold to Detroit, Grand Haven & Milwaukee Railway Company. Faithfully,

the ship roughed the sea year-round from Grand Haven, Michigan, to Milwaukee, Wisconsin. In the winter of 1885, while attempting to harbor at Grand Haven, it became locked in the ice for two weeks. During two weeks' time, the pressure from the ice squeezed its hull, which required extensive repairs. SS *Wisconsin*'s sister ship, SS *Michigan*, was less fortunate and sunk after being locked in ice for about four weeks.

In 1896, the *Wisconsin* was sold to Edward Gifford Crosby of the Crosby Line in Muskegon, Michigan. Its name was changed to the SS *Naomi* in 1898. Legend suggests that this name change was in memory of Crosby's daughter who had passed away in her childhood. Although its name may have changed, its route remained the same.

Disaster struck in the middle of Lake Michigan when the SS *Naomi* caught fire in May 1907. The SS *Curry* came to the rescue, but its crew was unable to save four crew members who were trapped below deck and perished. With the fire extinguished, the *Naomi* was towed back to Grand Haven and rebuilt.

Legend states that Crosby and his family boarded the ill-fated *Titanic* on April 12, 1912. His wife, Catherine, and daughter, Harriette, survived in a lifeboat. Edward's frozen body was found floating in the icy waters of the North Atlantic by a White Star Line recovery vessel. SS *Naomi*'s name was then changed to the SS *E.G. Crosby*.

The *E.G. Crosby* continued its cross-lake voyages until it was requisitioned by the United States Shipping Board and used as a convalescent hospital ship in 1918. It was then that its name changed again, this time to the *General Robert M. O'Reilly*.

After World War I ended, its name was changed yet again to SS *Pilgrim* when the steamer was purchased by the Seymour Line. The Seymour Line went under, and the ship ended up back in the possession of the Goodrich Line, its original owners. In 1924, Goodrich gave back its rightful name, SS *Wisconsin*, some forty-three years after its launching. It also assumed its original route from Milwaukee to Grand Haven.

They say that the fall of 1929 was a particularly stormy one on Lake Michigan. Two nights before Black Tuesday, the SS *Wisconsin* arrived at Milwaukee with a "pronounced list to port, and her cargo had shifted." On its final voyage to Milwaukee, it departed in extremely rough waters, and soon after began taking in water. Captain Morrison dropped anchor approximately six miles southeast of Kenosha and

HERE LIE THREE
CREW MEMBERS
OF THE S S WISCONSIN,
WHICH SANK IN THE STORMY
WATERS OF LAKE MICHIGAN
OFF KENOSHA, OCTOBER 29, 1929.
KNOWN ONLY TO GOD AND THOSE
WHO AWAITED THEIR RETURN.

The unknown crewmen of the SS *Wisconsin*. Recently, Hansen Lendman Funeral Home donated this stone and Monfils–Loewen Kenosha Monument Company donated the engraving for the three unidentified crewmen of the SS *Wisconsin* buried at Green Ridge Cemetery.

shut down the engines to make all power available to the pumps, and to wait out the storm. As the water level on the ship rose, a passenger gangway gave way, and even more water rushed in. Radio calls for help brought out the Coast Guard and some fishing boats to help those aboard.

Risking life and limb, the rescuers found a grim scene. In the proximity of the wreck, men were crying out in the water everywhere. Some were praying. Some were not moving at all. The search parties battled enormous waves as they fished the survivors from the lake. When all was said and done, fifty-nine people were saved, including Captain Morrison. Legend tells that he was unconscious until he made it to shore. At that time he stood up, shook hands with each crew member and then collapsed to the ground, where he died. The good citizens of Kenosha took care of the survivors. Nineteen people were rushed to hospitals. Forty more were taken to the police station and given warm clothes, hot food and coffee.

Investigations were launched to find out the cause of the ship's demise. After all, the SS *Wisconsin* had survived fifty-foot waves, high-speed winds and numerous storms for over forty-eight years. It was found that the previous voyage's damages may have caused the disaster. As the ship pitched and rolled in the rough waters near Milwaukee two days before, some cargo had broken free and slammed against the steel plates of the ship's hull. This may have weakened the structure, and it was not repaired. The subsequent storm sealed its fate, as the bashing waves found the weak spot in the hull.

Today, the SS *Wisconsin* rests on the bottom of Lake Michigan in approximately 130 feet of water, complete with its cargo, which includes a couple of automobiles. It is but one of about thirty vessels in history that have succumbed to Lake Michigan near Kenosha.

# LEWIS KNAPP, TOWN BLASPHEMER

Every town must surely have one, and for Kenosha, Lewis Knapp was the town "crackpot." He earned this title in the 1800s for erecting monuments around the city whose prose were always blasphemous in nature and sometimes spelled very poorly. A resident of Kenosha for nearly sixty-five years, he was eccentric but harmless. Most people thought of him as a nuisance, although a few were amused and entertained by him. He even had a few followers.

Knapp's life seemed relatively normal, by all accounts, until the years that preceded his wife's death in 1871. Mr. Knapp had come to Southport (Kenosha) in his twenties and remained here until 1849's gold rush called him westward. He returned a few years later and married Susan (Perrigo) Foster, and they then made their home in Kenosha.

Old Broad Gauge, as some people called him, labeled himself an "infidel," a philosopher and an inventor. It is said that he toyed with the idea of a perpetual motion machine, resulting in the nickname by which he came to be known.

The Knapp brothers (Lewis is pictured holding a dog on his lap). *Courtesy of the Kenosha County Historical Society.*

One thing that this colorful character never ran short on was grievances, particularly with organized religion. Another thing he never ran short on was words. Some of his rants came in at over eight hundred words. These he chiseled into monuments, which he erected in various public places within the city. Later, he also had his complaints and accusations cast into plaques, which were then attached to the monuments.

Most citizens were outraged at the "epitaphs" popping up in the city's parks, and the law intervened. It was ruled that Knapp couldn't erect his monuments in public places anymore. So instead, he started buying up cemetery plots at the City Cemetery (now Green Ridge) and erecting his tirades there. It seems that he had little to occupy his time after his wife's death, except his ever-increasing, outspoken hatred of the church. It is also interesting to note, however, that he barely missed a Sunday service, evidently so that he could gather fresh material to use against them. Old Broad Gauge consistently referred to the clergy as the "priestcraft" and used many other strange wordings that led some to question whether he had, in fact, been properly educated.

Lewis Knapp's writings were not limited to empty graves, for his epitaphs appeared on a few lucky friends' and family members' resting places as well. These strange monuments became somewhat of a curiosity among visitors—a tourist destination of sorts. The story goes that some curious folks were often surprised to find Knapp himself in the cemetery, spouting his anti-religious sentiments to anyone who would stay and listen. For the time being, it seemed as if this man had finally found the platform for his cause within the walls of the cemetery.

For over thirty years, Old Broad Gauge spouted his venom, until he died on Monday, January 24, 1898, at his home on Pearl Street. He had lived to see his eighties. He was laid to rest in Green Ridge Cemetery, next to his wife and brother, Daniel. Lewis's death was not a surprise to those who knew him well, as he had been ill for some time.

The *Kenosha Evening News* reported upon his death:

*Notwithstanding his very strong opinions and eccentricities he was a man who by his integrity, kindness and courage won many hearts. In religion, he owed allegiance to neither creed nor*

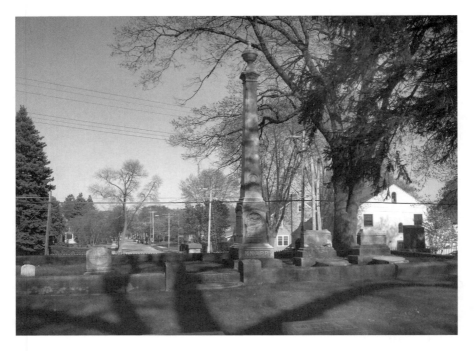

The Knapp family plot, Green Ridge Cemetery.

*dogma, measuring his life and actions by the stern laws of right and justice. Whatever the tenets which he conscientiously conceived and consistently maintained, he was always a man of strict moral character, a true citizen.*

In 1909, the president of the Kenosha Cemetery Association met with Knapp's remaining relatives in Chicago. The purpose of the meeting was to decide whether to remove Lewis Knapp's monuments. Three short days later, most of the monuments were gathered up and loaded into a boat. The stones were taken out a mile from the shoreline and dumped into the deep waters of Lake Michigan, never to be seen again. Nobody knows exactly how many there were, but the text of a limited number of them was recorded. The transcriptions are kept in a file in the archives at the Kenosha History Center. This epitaph graced the grave of a friend:

*To William Bruse*
*A purer or nobler soul never lived on earth. The earthly record of*
*William Bruse is one unbroken chain of unselfish, noble, kindly,*
*charitable deeds to poor unfortunates of earth. His body was*
*accidentally killed while performing one of his everyday charitable*
*acts of mercy and kindness. The nineteenth century priest-craft-*
*religion sends his soul to where damned devils roar and yell in*
*drimestone burning lake with fiery tongues and forked tails stirring*
*infants up in hellish glee, all because Bruse never joined the orthodox*
*church and liberally paid his tithes thereto.*

*Ye saintly, jeering, priest-rode simple apes, who scoffing read what*
*Knapp relates; Step lightly on this holy soddy, for fear Knapp might*
*have been your daddy.*

On another stone (a model of brevity), he stated simply, "I will
give \$1,000 reward for a virgin mother, I will. Lewis Knapp." As
time passed, Knapp's writings became much longer and even more
blasphemous in nature:

*Synopsis of the Nineteenth Century Religion*
*Oh, thou who in the heavens dost dwell, who as it pleases best thyself*
*sends one to heaven and millions to hell, and all for broken laws*
*thousands of years before their creation, through Eve's and Adam's*
*cause. Oh, Lord, pray bless they right reverends true, who in the*
*pulpits to women and children blather that we in fine clothes and*
*grace may shine unexcelled by saint and sinner at others cost, we pray,*
*let this be done and all the glory shall be thine and all for Christ's*
*sake. Amen. Amen*

*Human vampires, sordid, thieving, lying scoundrels have preyed*
*upon my labors and substance until I have writhed in anguish sore*
*even until life and I have seemed mismated and I feel that a restless,*
*wrathful, wandering spirit on some infernal hellish, fiery shore and*
*those who have thus plundered and robbed and swindled most have*
*been promoted and protected so to do by government protection laws,*
*also by the nineteenth century priest craft religion, which teaches*
*one Jesus will forgive and settle the bill. I hope to meet and loathe*
*and hate, ignore and expose to honorable souls those black-hearted*
*villainous sneak thieves in an endless eternity, I do.*

*Lewis Knapp.*
*As preachers prove from prophets that Jesus was God. Read about the prophets.*
  *3rd chap. v's 11, Mic.*
  *14th chap. 9th v's, Eze.*
  *20th chap, 6th and 7th v's, Her.*
  *23rd chap, 21st v's, Jer.*
  *23rd chap. 15th v's, Her.*
  *4th chap. 12th and 13th v's, Eze.*
  *28th chap. 15th v's, Jer.*
  *29th chap. 9th and 31st v's, Her.*
  *9th chap. 15th v's, Isa.*
  *14th chap. 9th v's, Eze.*
  *4th chap. 10th v's, Jer.*
  *2nd chap. 14th v's, Lam.*
  *20th chap. 25th v's, Eze.*
  *23rd chap. 11th and 13th v's, Jer.*
  *31st chap. 7th to the 40th v's, Num.*
  *1st Psalm, 15th chap. 3rd to 33rd v's, 16th chap. 6th v's, Deut.*
  *Read XXIII. And XXVII. Chapters of Jeremiah.*

*I will now relate the origin of the imaginary God's holy Christian Sunday, to-wit: 4,329 years after the Mosaical humbug of an imaginary god's imaginary creation and 325 years after the birth of Jesus, one Constantine, the fiftieth Roman emperor, for the first time the Christian Sunday was ever heard of, issued his imperial arbitrary decree to all the people of the Roman empire, and no one lese, he having no authority over other people, worded as follows, to-wit: "Let all people, judges, and trades rest on the venerable day of the Sun (Desolis). Those who live in the country, however may freely and without fault attend to the cultivation of their fields, since it often happens that no other day may be so suitable for sowing grain and planting the vine, and with the loss of favorable opportunity the commodities offered by divine providence would be destroyed." Now you know the date of the origin, word for word, of the Christian Sunday, all of which is studiously kept from the knowledge of hoodwinked and free priestly supporting dupes. All for Christs sake. Amen.*

Lewis Knapp's headstone.

*Who but a priest can well understand how to live six days without wirk on the fat of the land and work the government-forbidden one (not God-forbidden one) one day in seven, teaching women and children the cross roads to heaven? The hurrah for the good things everywhere to be paid for, the preaching, singing and praying about imaginary Gods and forked-tail devils, residing in space no astronomer knows where, always ending with, for Christs sake. Amen, and not one word about mammoth salaries and free vacations mentioned.*

Today, a lone monument remains intact in honor of Knapp's family. The headstones of Lewis and Susan and that of his brother Daniel and his wife Lucinda have all fallen victim to senseless vandalism. Daniel's and Lucinda's were removed and replaced with simple stones at some point. Lewis's and Susan's still lay near the ten-foot-tall memorial. Interestingly, nobody has ever filled in a death date for Lewis Knapp, who erected his own stone before his death.

*Old Broad Gage, Lewis Knapp*

*Aged (_____)*

*Emigrated (_____) to join his wife and other friends in the Celestial Field of Paradise thanking God for sense enough to die as he had lived for thirty years thoroughly infidel to all ancient and modern Theological humbug myths as taught for the fine clothes and place at others cost by an indolent egotistic self elected Priestly Crew. The fear of the Right Reverend Doctors of Divinity, theological scarecrow of Hell fire and damnation to all who refuse to pay tithes to their support, had no force or effect on Lewis Knapp.*

# POWDER PLANT EXPLOSIONS ROCK ENTIRE COUNTY

It was just after 8:00 p.m. on March 10, 1911. The residents of the village of Pleasant Prairie were no doubt settling down for the evening. There they were, minding their own business, when all of a sudden and without warning there was a massive explosion that shook everything in the area. People began to come out of their houses and saw the fire that was burning at the Laflin, Rand Co. (Hercules) powder plant, located near where the River Oaks and Chateau Plains subdivisions are today. Though this might have been very upsetting for some folks, the residents of Pleasant Prairie had already witnessed at least half a dozen similar explosions in the past. This one, however, would be very different.

Moments after the first explosion, a series of four blasts wrought total devastation on the peaceful little village of Pleasant Prairie. In a wave of tornado-like power, all fifty homes in the village were flattened in an instant. Half a mile away, a passing Chicago and Northwestern train had all of its windows blown out.

The King Store on the main corner of the village was shaken from its foundation. A piece of machinery flew through the roof and all of the floors, coming to rest in the cellar. The big boardinghouse along the main street was collapsed with the first explosion, and the entire place was ruined. Every single piece of glass for miles was broken.

The fire from the big plant continued to burn and light up the sky, and soon thousands of people traveled out to the scene to see for themselves the complete and total destruction that the blasts had caused. Simultaneously, residents began to realize that they were homeless as they walked the streets, undoubtedly in shock at what had transpired. Children had been snatched out of their beds, only to have no beds to return to. Many of Kenosha's families took in Pleasant Prairie families until their homes could be rebuilt or repaired.

Workers from the plant began to emerge from the wreckage, with only minor injuries. An informal roll was taken, and all of the employees were accounted for except for one. "Old Man Thompson" had been working in the glaze room, which was the location of the initial explosion. E.S. Thompson was characterized by his colleagues as being one of the most careful powder workers in the business. It was described in the newspaper as a sad scene when Mrs. Thompson walked up the street with her daughter, searching for Mr. Thompson,

and did not find him there with the others. He was presumed dead, and the sheriff was not letting anyone go look for survivors, for fear of more explosions. The next morning, when the area was deemed safe, the remains of Mr. Thompson were found. Portions of him had been scattered as far as two hundred feet away from the glaze room.

Remarkably, Old Man Thompson was the only casualty of this incident. As the villagers had headed outside after the first blast, they were not in their homes when the other four train cars full of dynamite detonated. Miraculously, all of the other workers managed to escape the ruins with cuts and bruises. The subsequent blasts caused a crater in the earth "large enough to hold a whole train of cars."

Pleasant Prairie and Bristol were the hardest hit by the destruction, but damage and injuries by flying shards of glass were reported from all four corners of the county. In Kenosha, factories near the lake almost seven miles away swayed as if there had been an earthquake, and heavy machinery that was fastened to the floors rocked to and fro. Fifty-five miles away in Chicago, there was $100,000 worth of damage to glass.

Lawyers for the company E.I. Dupont de NeMours Powder Co. took the initiative and immediately offered to pay all reasonable damages. Even so, the people of Pleasant Prairie started a movement to prevent the rebuilding of the powder plant at Pleasant Prairie. Their efforts proved unsuccessful. Laflin, Rand Co. employed 125 people. After the damages were repaid, the factory was rebuilt. But 4 more people would lose their lives before the powder plant ceased operations in Kenosha County. In its thirty-one years of operation, there were at least twelve explosions and three fires. In all, 18 deaths occurred as a result of explosions at the plant.

# A Mother's Love

On March 17, 1911, the residents of Kenosha were busy cleaning up debris caused by the massive powder plant explosion that had occurred only the week before. Usually, by March, the weather is moderately

Southport Park Beach, the approximate area that lies east of what was then called Butcher Road.

cold, with only brief, fleeting previews of nicer weather to come. This is a season when it can be sixty-five degrees one day and a foot of snowfall the next. Lake Michigan is oftentimes still encrusted with snow-capped ice near the shoreline well into the month of April.

On this cold morning, twenty-four-year-old Anna Fullmer started out of her house to take a walk outside in the open air, as had become her normal routine. As she started out, her three-year-old daughter, Beatrice, begged to accompany her, and soon after left the house with her mother. It was reported that Mrs. Fullmer seemed to be in good spirits as they started out on their morning excursion.

Hand in hand, the mother and child left their home and walked south to Butcher Road (South Sixth Avenue), which was, at that time, approximately a half mile south of the city limits. The two then turned east and headed forward, directly toward the lake. Herbert and John Butcher, brothers, watched them walk through a long stretch of sand until they came to the water's edge. To the men's horror, Mrs.

Fullmer then clasped the hand of the child and deliberately leaped into the freezing water. The Butchers, at once realizing the severity of the situation, started running down to the water to assist, but they were almost a quarter mile away from the scene when it happened. Together, they witnessed Mrs. Fullmer, seemingly emotionless, as she continued to travel farther into the surf. Reportedly, the woman seemed to be completely oblivious of anything that was going on around her. They continued farther out until the waves swept over the head of little Beatrice, and then the lake finally snatched the child out of her mother's grasp.

Apparently, it wasn't until that exact moment that she returned to her senses and started earnestly struggling to rescue her helpless daughter. A bitter struggle ensued between the young mother and the strong currents of our mighty and powerful Lake Michigan. The Butchers, running full speed toward the beach and watching helplessly, were certain that the little girl would be lost to the water, if not the mother as well. By the time they reached the shore, however, Anna Fullmer had somehow dragged her baby girl out of the water. Both were exhausted and collapsed on the sand. It was then that the men finally arrived at the scene.

The Butcher brothers carried mother and child to a house in the neighborhood, where the mother pleaded with the women of the house to care for the child but refused any warm clothes or blankets for herself. Beatrice was shaking violently and was immediately wrapped in warm blankets and comforted until the "police ambulance" arrived to take them into the city for medical attention. It was reported in the evening newspaper that although both Mrs. Fullmer and Anna had suffered terribly from exposure, both were expected to make a full recovery.

Later, Mary Monigan, Anna Fullmer's mother, told authorities that her daughter had been mentally ill for some time, and that she had even spent some time in a sanitarium due to her history of suffering from "mental trouble." Mrs. Fullmer seemed to have no recollection of the episode after returning home later on in the day.

It never became apparent for sure whether she had meant to drown herself and her small child or if she had been under the influence of some dark hallucination. Mrs. Fullmer had first begun taking the daily long walks out in the open air on the advice of her physicians to help improve her state of mental health.

# LOCAL MAN INVENTED SUICIDE DEVICE

Howard E. Harbaugh was thought of as a mechanical genius. The son of Mr. and Mrs. George J. Harbaugh, he was born in Hagerstown, Maryland, on April 7, 1862. Just before coming to Kenosha, he lived for a time in Rockford, Illinois. Harbaugh moved to Kenosha in 1892 and was employed by the Chicago-Rockford Hosiery Company as an inventor.

Howard Harbaugh had several inventions to his credit, but he never acquired any real wealth from them because all the patents belonged to the company for which he worked. First, he invented the automatic circle knitting machine. It was widely received and soon was used in most knitting mills of that day. Then he invented a wire-weaving machine to weave wire springs for mattresses. In time, this invention also became widely known and used. It is said that he created literally hundreds of smaller inventions while he was employed by the hosiery company. Howard continued to work there until his health deteriorated, at which time he retired. During the last twenty-six years of his life, he mourned heavily his only son, Charlie, who had passed away just after he graduated Kenosha High School at the age of eighteen.

After his retirement, Harbaugh was often seen around the neighborhood using a cane to help him walk. He always wore a pair of spectacles down low on his nose. As time passed, his steps grew more and more unsteady, and his "nervousness" grew worse with time. His grief, together with his failing health, robbed him of his golden years.

Howard was sixty-eight when he went out to his garage one last time, behind his home then located at 1411 Sixtieth Street. Like for most men, his garage was a place where he had spent many hours thinking or tinkering with ideas and gadgets. On April 24, 1930, for the first time in his life, old man Harbaugh used his ingenious talent to invent a device of destruction.

A 12-gauge shotgun was positioned in a vice. A slender strap was tied to the trigger and ran backward to the stock of the gun. The strap then traveled upward and over an awl (a pointed tool with a

handle, resembling an ice pick), which he had driven into the wall. The strap then hung directly in front of the muzzle of the shotgun. At some point, he must have put a shell in the chamber. Harbaugh then apparently pulled the strap after placing his face directly in front of the barrel.

Nobody heard the shotgun blast, but his body was found around suppertime. The coroner was called, and he took the remains to Crossin Funeral Home. Later, the remains were brought back to the home, after which they were taken to Rockford, Illinois, for burial.

## THE MAGICAL WATERS OF THE BRISTOL SODA SPRINGS

During the nineteenth century, soda waters were believed to be the cure for just about anything that one could suffer from. A soda spring is a natural occurrence, defined as being a "bubbling spring of carbonated water." This happens sometimes when plain old everyday water seeps into the soil in the earth and becomes part of the groundwater supply. The groundwater then travels through underground natural waterways and all sorts of different rock formations, all the while picking up minerals and properties of the rocks with which they have come into contact. The properties that the spring water adopts depend solely on which kinds of minerals and elements the water comes into contact with. Sometimes the material the groundwater picked up would have effervescent qualities, much like carbonated soda pop; such was the case with the healing soda springs of Bristol, Wisconsin.

During the nineteenth century, these types of water treatments, called water cures, were held in the highest regard. It was widely believed that soda spring water possessed healing qualities. Dating before the 1800s, Native Americans were aware of the benefits of these "healing waters." The ancient Greeks also believed in the medical properties of these odd, somewhat rare sites. Those who possessed land that housed a soda spring could capitalize on the situation, as

some people were willing to travel hundreds of miles to drink of or soak in their mysterious, magical waters.

The town of Bristol is located in the south-central section of Kenosha County. It is a relatively quiet area where farming has always been big business. In a section within the town of Bristol called Woodworth, a man named James Eddy, along with his parents and family, settled on a farm a few miles north of the location of the springs in 1844. After he was grown, in 1867, the younger Eddy left his father's farm and purchased eighty acres of land a few miles south of there. He began clearing the land to plant wheat. James Eddy had first learned of the soda springs shortly after arriving with his family to the area. All of his friends and family members used the series of mineral springs at their leisure, but they didn't give much thought to the "special" qualities that it contained.

At that time, though, soda springs water was believed to be a miraculous cure for just about anything, from heartburn to diabetes. The Bristol soda springs would later be advertised as a cure-all for "Heart-burn, dropsy [edema], nervousness, dyspepsia [indigestion], rheumatism, chronic inflammation of the bladder, liver complaint, constipation, inflammation of the kidneys, bowels and all inflammations, both acute and chronic, diabetes, Bright's disease [severe kidney ailment], piles [hemorrhoids], and general debility [weakness], etc." This new insight all reportedly stemmed back to one source: Mrs. Pheobe Moore of Rockton, Illinois.

Poor Mrs. Moore suffered from edema (swelling) in her later years. Her advanced condition made her miserable most of the days of her life. She came, in 1871, to visit friends in the area. After two months of ingesting the soda water, she claimed to be wholly cured, and insisted that her health was "restored to perfect soundness."

Soon, others came forward and claimed that they, too, had been cured by the miraculous powers of the soda springs. Even a few reputable physicians wrote testimonials touting the positive health benefits of using the springs. James Eddy started to envision the money-making potential that he was sitting on, and together with a neighbor, John D. Benedict, began to cash in on his most fortunate position.

They had a chemist analyze a sample of a gallon from the springs. Afterward, it was found that the water from the soda springs contained 8.888 grains of bicarbonate of soda and 7.739 grains of sulfate of soda. The soda springs were designated as more than qualifying

for the requirements of being a true soda spring. Over the years, approximately thirty such springs have been officially documented in the state of Wisconsin.

Surprisingly, there was never a charge for visitors who came and used the soda springs. They were encouraged to use them for free. At the springs, Eddy and Benedict built a wooden structure that was used as a bathhouse. It is said that they also had plans to build a hotel, which never ended up being built. Eddy and Benedict were wise to the fact that visitors would feel that the waters had benefitted their health and would then want to continue their "treatments," and they were right. The water would then be hauled to the train station in Woodworth and sold to the general public for twenty-five cents per gallon, or eight dollars for a full thirty-two-gallon barrel. (If one furnished his own barrel, he received a two-dollar discount.) Local druggists and Dr. Pennoyer (of the Kenosha Water Cure) enjoyed steep discounts on all of their orders.

As the years passed, the curiosity over the Bristol soda springs just sort of fizzled out. Physicians voiced skepticism of any real healing properties of such kinds of water, believing that any positive effects on a person's health were more than likely the result of the inflicted person resting in a relaxing, comfortable state. Today, we may call it a "spa treatment."

Over the years, this property—which is located approximately one third of a mile northwest of today's intersection of County Roads C and MB—passed through many members of that Eddy family, and folks seemed to pretty much forget about the soda springs at Bristol. However, in the early to mid-1980s, they were still known to be there.

# BIBLIOGRAPHY

Burckel, Nicholas C., ed. *Kenosha: Historical Sketches*. Kenosha, WI: Kenosha County History Committee, 1986.

Burckel, Nicholas C., and John A. Neuenschwander, eds. *Kenosha Retrospective: A Biographical Approach*. Kenosha, WI: Kenosha County Bicentennial Commission, 1981.

Cartwright, Carol Lohry. *Kenosha Historic Districts*. Kenosha, WI: 1988.

Cinema Treasures Website. "Rhode Opera House." http://cinematreasures.org/theater/3361.

Collections of the State Historical Society of Wisconsin, vol. 6. Lyman, Copeland, Draper, LLD. http://books.google.com.

*Commemorative Biographical Record of Prominent and Representative Men of Racine and Kenosha Counties, Wisconsin*. J.H. Beers & Co. http://books. google.com.

Cropley, Carrie. *The Case of John McCaffary*. Kenosha, WI: 1952.

———. *Kenosha: From Pioneer Village to Modern City 1835–1935*. Kenosha, WI: 1958.

———. *The Potawatomi in Kenosha County, Wisconsin*. Kenosha, WI: 1962[?].

Day, Arlyn, ed. *Ghosts of Kenosha County*. Kenosha, WI: Kenosha Public Library, 2005.

———. *The Legend of John McCaffary*. Kenosha, WI: Kenosha Public Library, 1999.

Engberg, Mable Glasman, comp. *Bristol Heritage*. Bristol, WI: 1976.

Gen Web. "Kenosha County, WI." http://www.rootsweb.ancestry.com.

Giles, Diane. "A Hunting They Will Go." *Kenosha Bulletin*, September 17, 2001.

———. "That History Column: After 31 Years, Woman's Club Finally Found a Home." *Kenosha News*, April 5, 2009.

Godfrey, Linda. "The Beast of Bray Road—Tailing Wisconsin's Werewolf." *Wisconsin Werewolf*, 2003.

———. *Strange Wisconsin: More Badger State Weirdness*. N.p.: 2007.

Heritage Preservation Associates, Inc., MacDonald and Mack Partnership. "Building Kenosha." Kenosha, WI: Department of Community Development, 1982.

Jensen, Don. *By Tempest Toss'd*. Kenosha, WI: 2003.

———. "Ghosts of Kemper Past." *Kenosha News*, October 29, 1995.

———. "Hangman's Work Here Changed Law." *Kenosha News*, February 23, 1978.

———. "'Haunt' Now Historic." *Kenosha News*, February 23, 1978.

———. *Kenosha: A History of Our Town*. Kenosha, WI: 2005.

————. *Kenosha Kaleidoscope: Images of the Past*. Kenosha, WI: 1985.

Kemper Center, Inc. www.kempercenter.com.

Kenosha Cemetery Association. "Green Ridge Cemetery Has Room for You." Undated pamphlet handed out at Green Ridge Cemetery.

Kenosha County Historical Society and History Center Archives. Lewis Knapp vertical file.

*Kenosha Evening News*. "County Swept by Explosion." March 10, 1911.

————. "Find It Was Suicide." January 9, 1900.

————. "Gateway Opens Tonight with Huge Program." December 29, 1927.

————. "Gives Up Its Dead." January 8, 1900.

————. "Lewis Knapp Is Dead." January 25, 1898.

————. "Local Inventor Invents Device to Kill Self." April 25, 1930.

————. "Mystery Is Solved." January 5, 1900.

————. "Sister Margaret Clare Dies at Kemper Hall." September 16, 1921.

————. "A Strange Case." January 4, 1900.

————. "Went into the Lake." March 17, 1911.

Kenosha History Center. "Historical Districts" and "Historic Photos." http://www.kenoshahistorycenter.org.

*Kenosha News*. "Highway Accidents Kill Four Kenoshans." May 20, 1968.

————. "Read All About It: 100 Years of the *Kenosha News*." 1994.

Kenosha Paranormal. "Urban Legends" and "Ghosts & Hauntings." http://www.kenoshaparanormal.com.

Kenosha Unified School District. *Kenosha: Past to Present*. Kenosha, WI: 1985.

Lyman, Frank H. *City of Kenosha and Kenosha County, Wisconsin*. vol. 1. Kenosha, WI: 1916.

Metro, Debbie Luebke. "Ghost Walks at Tavern." *Kenosha News*, October 30. 1995.

————. "Kenoshan Finds Ghostly Image in Wedding Photo." *Kenosha News*, July 29, 1996.

————. "Residents Say Woman Murdered in 1850 Haunts Local House." *Kenosha News*, October 31, 1999.

————. "She Walks by Night." *Kenosha News*, October 26, 1997.

————. "Simmons Staff Reports Ghostly Encounters." *Kenosha News*, October 21, 2001.

————. "There's More to the House Ghost Story." *Kenosha News*, November 8, 1999.

Rhode Opera House. "Legends & Ghost Stories." http://rhodeopera.com/ghosts.html.

Robbins, William E. "Eye in the Sky." *Kenosha News*, October 24, 1991.

————. "Ghost of Kemper Center." *Kenosha News*, October 26, 2003.

Ruenzel, Wendy. "Rhode Volunteers, Guests Participate in Hunt for Ghosts." *Kenosha News*, October 21, 2001.

Saucerman, Greg. *Summer Enchantment: The History of Twin Lakes*. Twin Lakes, WI: Western Kenosha County Historical Society, 1994.

Sister Mary Hilary, CSM. "Ten Decades of Praise, the Story of the Community of Saint Mary During its First Century 1865–1965." Project Canterbury. http://anglicanhistory.org/usa/csm/mhilary/chapter11.html.

Taylor, Troy. "Kemper Hall, Kenosha, Wisconsin." Ghosts of the Prairie: Haunted Wisconsin. http://www.prairieghosts.com/kemper_1.html.

University of Wisconsin, Madison—Libraries. "Antiquities of Wisconsin, as Surveyed and Described." http://www.library.wisc.edu/etext/Antiquities/antiqHome.html#TOC.

Wisconsin's Great Lakes Shipwrecks. "SS *Wisconsin*, Service History." http://www.wisconsinshipwrecks.org/explore_wisconsin_serv.cfm.

Visit us at
www.historypress.net